IMAGES
of America

JEFFERSON COUNTY

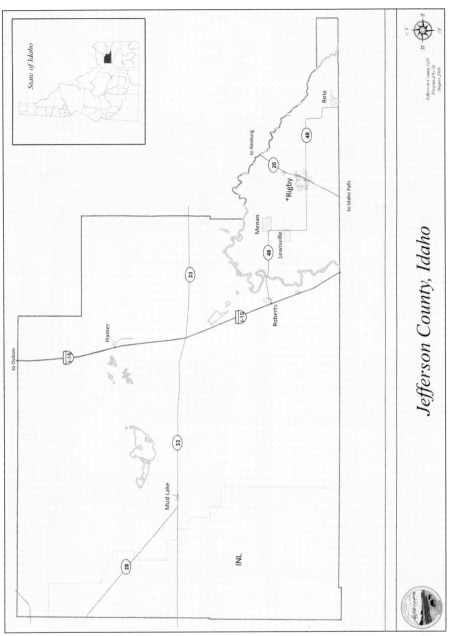

This general map shows the communities, lakes, rivers, and major highways and roads of Jefferson County. (Courtesy Jefferson County Assessor's Office.)

ON THE COVER: The Great Feeder Canal represents one of the most remarkable pioneer irrigation efforts in the American West. Water is the lifeblood of Jefferson County, and when water did not enter the Dry Bed Channel in 1894, farmers went without it. To survive, action had to be taken. Canal companies and farmers joined together to construct a headgate and dig a canal to divert water from the Snake River to its Dry Bed Channel. Their herculean efforts were celebrated on June 22, 1895, with water entering the new canal. This photograph shows project workers in 1895. (Courtesy Jefferson County Historical Society [JCHS].)

IMAGES of America
JEFFERSON COUNTY

Patricia Lyn Scott and Marjorie J. Scott

Copyright © 2009 by Patricia Lyn Scott and Marjorie J. Scott
ISBN 978-0-7385-5998-8

Published by Arcadia Publishing
Charleston SC, Chicago IL, Portsmouth NH, San Francisco CA

Printed in the United States of America

Library of Congress Catalog Card Number: 2008933034

For all general information contact Arcadia Publishing at:
Telephone 843-853-2070
Fax 843-853-0044
E-mail sales@arcadiapublishing.com
For customer service and orders:
Toll-Free 1-888-313-2665

Visit us on the Internet at www.arcadiapublishing.com

In memory of Hope Bennett Jones (1899–1979), former editor of the Rigby Star, who did not see the completion of her Jefferson County history but inspired us.

CONTENTS

Acknowledgments		6
Introduction		7
1.	And Then They Came	9
2.	Organizing Communities	15
3.	Water Is Everything	25
4.	One County, Two County, Three County, Four . . .	33
5.	Boom, Bust, and Depression: 1900–1940	39
6.	Agriculture, Business, and Industry	57
7.	Civic and Social Life	83
8.	Commitment to Serve	103
9.	The Rock Buildings of Jefferson County	111
10.	The Unexpected: Blizzards, Floods, Fires, Outlaws, and More	117
Bibliography		126

ACKNOWLEDGMENTS

This book was only possible because of the support and assistance of various individuals and institutions. Special thanks to the Jefferson County Historical Society (JCHS) for the use of all their historical resources and for providing many of the photographs used in this book. It would have been impossible without their complete support and cooperation. The kindness and the generosity of the following institutions has truly been remarkable: the Bonneville Historical Society, especially LaDean Harmston, Judy House, and Annie Marie Jones; the Upper Snake River Valley Historical Society (USRVHS) and Louis Clements; the Mud Lake Historical Society (MLHS) and Orvin W. Twitchell; archivist John L. Powell and director Martin Raisch of the David O. McKay Library, Brigham Young University–Idaho (BYU-I); Bill Hathaway and editor Dean Miller of the *Post Register*; Karen Kearns of the Idaho State University, Eli Obler Library Special Collections; Jared Miller and Idahoan Food, LLC; Dan Davis of the Cazier-Merrill Library, Utah State University; the Idaho Historical Society; and the Utah State Historical Society.

We acknowledge the contributions of the following individuals providing photographs and information to this effort: W. Dale Armstrong, Julie A. Black-Fife, C. Richard Broulim, Douglas D. Crossley, Bruce A. Eckersell, Gwen Ellsworth, Melvin J. and John Hansen, Jerry O. Jensen, Lois Jones, George and Joyce Marriott, Myrtle Reddick, Marlene S. Reid, Timothy Rounds, Dave Sanders, Eldon Scott, Enid Storer, Bartley and Nedine Stowell, Guen R. Taylor, and especially Sherry Lufkin. We appreciate the assistance and the patience of our friends Jerry Glenn and Lavina Fielding Anderson in reading chapter introductions. The endorsement of the Jefferson County Commission provided early support to our efforts. The level of support and encouragement from the *Jefferson Star* has been amazing and has sustained us during the stressful times. We acknowledge the support and assistance of friends, colleagues, and family. Special thanks to Sharon Peters, Ashley Rackham, Dallin and Krystal Vanleuven, and Linda Thatcher.

INTRODUCTION

This book tells the story of the settlement, growth, development, and people of Jefferson County. Located entirely on the Snake River Plain, it is one of the most uniformly level counties in Idaho. Its elevation ranges from 4,780 feet to 5,200 feet, the only exception being a very small section east of Heise that reaches 6,469 feet. It is located mainly north and west of the bend in the Snake River that sends its flow from the northwest southward. The bend, controlled by the Menan Buttes, allows Jefferson County to have large areas of rich irrigated farms to the south and east near Rigby and Roberts. The county's northern and western sections consist primarily of basalt lava, with Mud Lake as a sedimentary basin in the northwest corner. Irrigated farming also flourishes around Mud Lake, its soil formed from the ancient bed of Lake Terreton. The northeast corner of the Idaho National Laboratory occupies the western edge of Jefferson County.

For centuries, the Shoshone and Bannock inhabited the area. They were among the earliest Idaho tribes to acquire horses and hunt the buffalo that were once plentiful in the region. Fur trappers frequented the area, and explorers and surveyors traversed it, but white settlement came slowly. It was not until the 1860s, with the establishment of freight lines from Corinne, Utah, to the Montana goldfields, that a permanent settlement was established at Market Lake. It was another decade before a significant number of families arrived in the area. During the construction of the Utah and Northern Railroad, members of grading crews spread descriptions of the area's fertile soil and plentiful water among their relatives in Utah. By 1900, almost a dozen communities had taken root in the eastern part of the county. Between 1900 and 1930, the Mud Lake area was developed by diverting the waters of Camas Creek, establishing pumping wells, and pumping irrigation water from Mud Lake. By 1929, three hundred wells were in production.

While the entire county has been described as being politically and socially very conservative, the two regions have distinct social characteristics. Randy Stapilus, in his *Idaho Political Almanac*, has described the people of the west (Hamer, Monteview, Mud Lake, and Terreton) as being more "insulated and strongly independent." These differences reflect their founding history. Eastern Jefferson County was settled largely by Utah Mormons, while western settlers represented a greater religious and background diversity. Settlement was relatively easy in the east, while establishing homes and farms in the western areas was a daily struggle. These differences were intensified by the distances between the two areas that fostered separate development. These distances required independence and that spawned an intense hometown pride. Today I-15 makes it easier to travel north to Clark County and south to Idaho Falls, while State Highway 33 provides easier access to Rexburg than the series of state roads required for reaching eastern communities. There are few opportunities to bring the two regions together. There are separate school districts, and each region has its own telephone system and its own telephone directory.

The county's population remained fairly stable from 1950 to 2000, with increases remaining under 10 percent for decades. The situation changed dramatically after 2002, when Rigby was hit with a major housing boom. In the next five years, more than a dozen new housing developments emerged east, south, and northwest of Rigby, with the population in eastern Jefferson County

increasing by more than 16 percent. Many new residents worked in either Idaho Falls or Rexburg and found that travel from Rigby was more than offset by the cheaper housing and rural life.

This book is the first written on Jefferson County since Willard Adams's *100 Years of Jefferson County* in the 1960s. Adams was a remarkable individual, the son of the first white child born in Jefferson County. His account was also a memoir full of his own observations on the founding and development of Jefferson County. It is an important starting point for anyone interested in Jefferson County. It has been out of print for decades and is only available at local libraries. Others (including Hope Jones) have spoken about writing county histories, but they have not materialized. Histories have been published on most communities and many Church of Latter-day Saint (LDS) wards within the county.

This book is organized into 10 chapters. The first five chapters trace chronologically the history of Jefferson County, while the remaining five show the developments in Jefferson County by subject category. Our primary goal in writing this book is to represent every region of the county, not just Rigby and Roberts. Photographs have been collected from institutions in Utah and Idaho and from a number of individuals. Jefferson County has a remarkable story and we are excited to present a slice as an introduction. We hope it will encourage the writing of a more definitive history. There remains only four years until Jefferson County celebrates its centennial year.

One
AND THEN THEY CAME

The Shoshone and Bannock tribes were the first inhabitants of the Upper Snake River Valley. They wintered in the Fort Hall–Pocatello area, moving north and east in the spring to fish the waters of the Snake, to hunt game along its tributaries, and to pursue buffalo on its plateaus. Having a successful hunting season was critical to their survival during the long winters. The Snake River's spring floods fed the marshes west of the river, making it, as author Vardis Fisher wrote, a "rich market in fowl and wildlife." The area became a favorite campsite and was named Market Lake.

The first visitors to the area were the fur trappers seeking beavers and other fur-bearing animals in the Snake River and its tributaries. The first to arrive in 1810 was Andrew Henry's trapping expedition to the headwaters of the Missouri River. They found the beaver plentiful but, forced southward by repeated attacks from the Blackfeet, built temporary Fort Henry near the present site of St. Anthony. Other high-profile expeditions were those of Wilson Price Hunt in 1811, Peter Skeen Ogden in 1828, Capt. Benjamin Bonneville in 1832, and Nathaniel J. Wyeth in 1834. The 1850s saw the decline and the eventual end of the Rocky Mountain fur trade. The last trapper and first permanent settler in the area was Richard "Beaver Dick" Leigh in about 1858.

Gold discoveries in Montana in 1864 caused the establishment of the first regular stage and freight lines through eastern Idaho. Later that year, Matt Taylor, a freighter, built a bridge over the Snake River at a site that became Eagle Rock (now Idaho Falls). On October 6, 1868, the Adams family became the first settlers in Market Lake. That same year, Israel Heald, a former trapper, settled at the forks of the Snakes and began running cattle. The area was commonly called "The Island," a 25-mile-long, 3-mile-wide stretch of land bordered on the north by the Snake River and on the south by the Dry Bed Channel and was soon called "Heald's Island." The Montana Trail through the Upper Snake River Valley became a major route to and from the Montana goldfields.

Started in 1873, the Utah and Northern Railroad built northward from Brigham City, Utah, but due to financial difficulties, it did not reach Pocatello until August 1878 and Eagle Rock and Market Lake in April 1879. Clearly the railroad was responsible for the settlement of the Upper Snake River Valley.

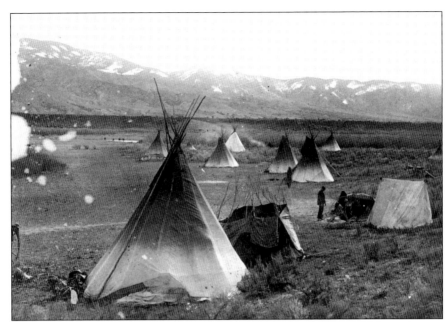

The territory of the Shoshone and Bannock extended across most of southern Idaho and into western Wyoming. In the spring, they divided into bands to gather food. While some hunted, others fished, and still others searched for berries and roots. They were preparing for the long winters. The above photograph shows tribal members camped in Pocatello in 1882. Below is a William Henry Jackson photograph of a Bannock family (Sheepeater band) camped along the Medicine Lodge Creek in 1871. (Above, courtesy A. L. Lillibridge Collection, Idaho State University Special Collections; below, Special Collections and Archives, Merrill-Cazier Library, Utah State University.)

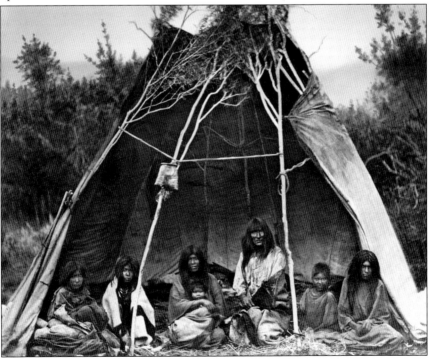

10

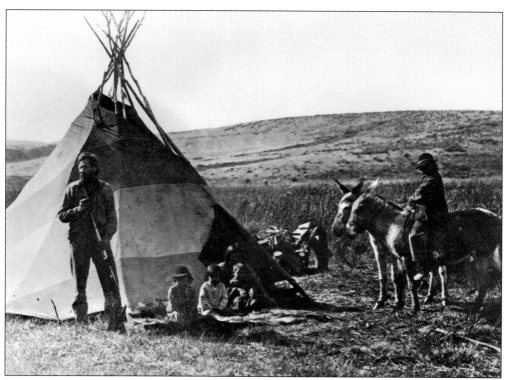

Richard "Beaver Dick" Leigh (1831–1899) was born in England and at seven stowed away aboard the ship his sister and brother-in-law were immigrating to the United States on. He started trapping for the Hudson Bay Company in Wyoming. For 25 years, he trapped for various fur companies. He and his Shoshone wife, Jenny, and children settled north of the Menan Buttes in the Yankee Fork country. For many years, he operated a ferry. During the winter of 1876–1877, Jenny and their five children died of smallpox. Three years later, he married a 14-year-old Bannock woman, and she bore him three children. This picture shows Leigh standing to the left with his first family. (Courtesy Bonneville Historical Society and Museum of Idaho.)

Israel Heald (1818–1894) was a 1860s cattleman with land holdings from Eagle Rock to Menan. He became the Eagle Rock postmaster (1869–1880). He left Idaho for Maine in the 1880s. He sold his last ranch land and Market Lake town lots in 1891. No picture of Heald has been located; this photograph shows part of the area called Heald's Island, looking west from Menan to the Market Lake area. (Courtesy Patricia Lyn Scott [PLS].)

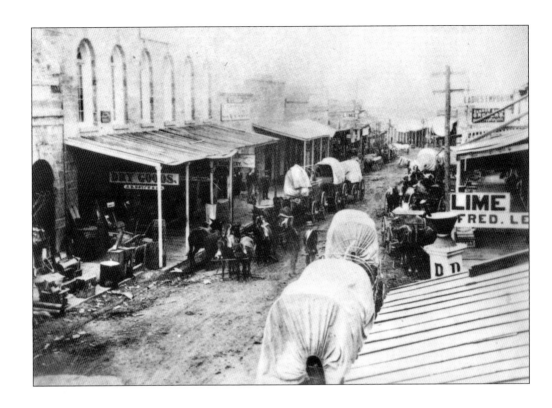

Between 1872 and 1879, sixty thousand tons of supplies were transported along the Montana Trail from Corinne, Utah, through eastern Idaho to the gold camps of Montana. The 1868 photograph above shows freight wagons arriving in a gold camp in Montana. In 1868, a stage contract was signed to establish home stations every 50 miles along the route and 30 or 40 swing stations where teams were changed and cramped limbs could be stretched. The three stations established in what would become Jefferson County were Market Lake, Sand Hole (Hamer), and Camas. The photograph below shows a stage arriving at the Market Lake Station in 1874. (Above, courtesy Special Collections and Archives, Merrill-Cazier Library, Utah State University and the Utah Historical Society; below, Upper Snake River Valley Historical Society [USRVHS].)

Brothers William J. (1834–1904) and John N. (1833–1885) Adams and partner Thomas N. Lauder (1832–1899) purchased a freight outfit and supplies and traveled north along the Montana Trail. They stopped near Market Lake and made camp. Thrilled at the acres of wild hay, they staked out their claims. They became the first settlers to the area. William (above, with wife Mary Ann) took the saddle horse and headed south to file their land claims while his brother (at right, with his wife Lovina) and Lauder continued to Virginia City, Montana, to deliver the supplies. On October 6, 1868, Mary Ann wrote in the family Bible, "We arrived at the Market Lake Stage Station." They first lived in their wagon box with canvas stretched over it. William could find no timber or lumber near their dwelling. Using a damaged headgate, driftwood, and tent material, a protected structure was created. Mary Ann Adams gave birth to a son, William Joseph "Newt" Adams, on December 13, 1870. (Above, courtesy Marlene S. Reid; at right, USRVHS.)

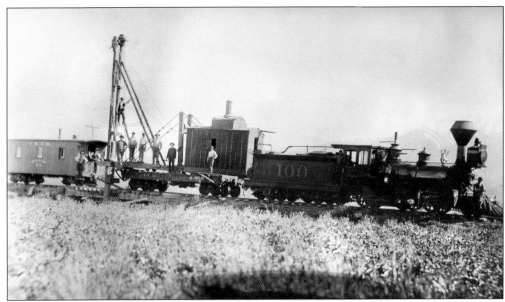

The Utah and Northern Railroad was largely responsible for the settlement and development of eastern Idaho. Construction started in Brigham City, Utah, on August 26, 1871. Since financing was difficult, construction progressed slowly and then stalled until 1878. The tracks reached Pocatello in August 1878 and stopped for the winter in Blackfoot in December. It was a very mild winter, so work was only stopped for a couple of months. In April 1879, the line reached Eagle Rock (Idaho Falls), then Market Lake and Camas by the fall. The picture shows a grading crew being transported through the Portneuf Canyon near Inkom in 1878. (Courtesy Merrill D. Beal Papers, David O. McKay Library, Brigham Young University-Idaho.)

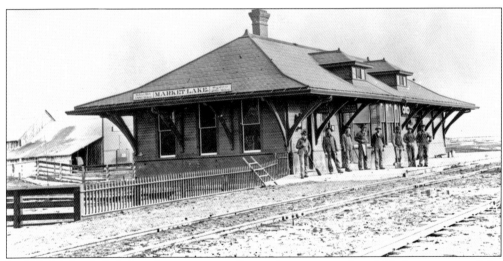

In 1879, Market Lake's first depot was a small, wooden structure. It quickly became one of the busiest depots in the system, open 24 hours a day. It had three telegraphers, freight and passenger agents, and section crews. In 1880, Market Lake boasted a population of 140, which included 32 railroad employees. This photograph shows the depot in 1898. (Courtesy USRVHS.)

Two

Organizing Communities

Historian Leonard J. Arrington declared February 10, 1879, the day the "settlement process" began when John R. Poole, a grading crew member of the Utah and Northern Railroad, went "deer hunting on lake bottom land north" of Market Lake. Poole was impressed by the land and, wanting to homestead, asked permission of Israel Heald. Heald reportedly replied: "I don't believe God intended that a few men should have all this great country to raise horses and cows in." Soon Poole was urging his Utah friends to join him. Joseph C. Fisher was the first to follow in 1879, and others soon followed. Heald's Island soon became Poole's Island, then Cedar Buttes, and finally Menan after a native word meaning "island."

During the 1880s, Menan became the parent of at least nine separate communities in the Upper Snake River Valley. These communities were settled by individual families, not by organized group efforts. Most of the settlers were Mormons from Utah and easily employed the cooperative work patterns used in other Mormon communities in Idaho such as Franklin and Paris. Since they lived on their own 160 acres and not in towns, their communities appeared very scattered. Soon the settlers organized congregations (wards) and constructed church and school buildings. The 1879–1900 period was a formative one in which many of Jefferson County's communities were founded, including Menan (1879), Annis (1879), Lewisville (1882), Lorenzo (1880), Rigby (1883), Labelle (1886), Grant (1889), and Garfield (1898).

In May 1890, Andrew Jenson, an assistant historian of the Church of Jesus Christ of Latter-day Saints (LDS) Historian's Office, accompanied LDS apostle Marriner W. Merrill to the Bannock Stake Conference, then toured the settlements north of Eagle Rock (Idaho Falls). Jenson reported in the *Deseret News* that the Bannock Stake "embraces twenty organized wards with a total membership of about four thousand," adding that nine of the wards were located south of the main channel of the Snake River. His report was one of the first accounts published about the founding of the Labelle, Lewisville, Menan, and Rigby Wards.

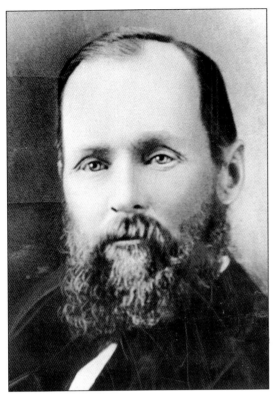

John R. Poole (1829–1894) was a Mormon convert who immigrated to Utah in 1850. In 1878, he became a railroad-grading contractor for the Utah and Northern Railroad. They camped for the 1878–1879 winter at Market Lake. He toured the area and was impressed by "The Island." He returned to Ogden, held a public meeting, and described his findings. Twenty families moved to the area in the summer of 1879. He moved there in the fall of 1879. He was also instrumental in almost all developments in the community including the building of a meetinghouse, a school, the first canal, and brought the first threshing machine to the area. (Courtesy JCHS.)

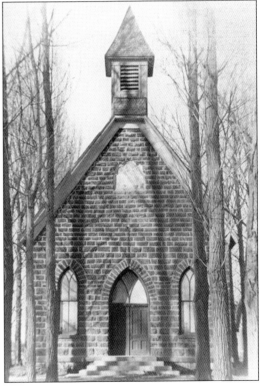

Construction began on the Menan Rock Church in the spring of 1891 and was completed in 1899. The Menan church was used by the LDS for 41 years. The rock was quarried from the south side of the Menan Buttes and was brought across the river by boat until a bridge was completed in 1892. Its interior consisted of a long narrow room with a high ceiling, long wooden benches, two pot-bellied stoves, and windows along its west walls. (Courtesy JCHS.)

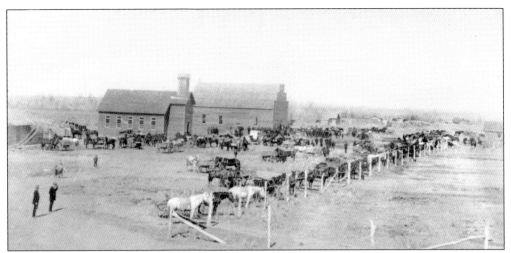

The first school was established in Menan in 1881. It was held in a one-room school built and moved to the town site. The first teachers were Jennette and Susanna Poole, John Poole's wife and daughter. When the building burned down in 1882, school was suspended until a new school was constructed. This picture shows Menan's second school and amusement hall in 1895. A newer and larger building was constructed in 1909. (Courtesy JCHS.)

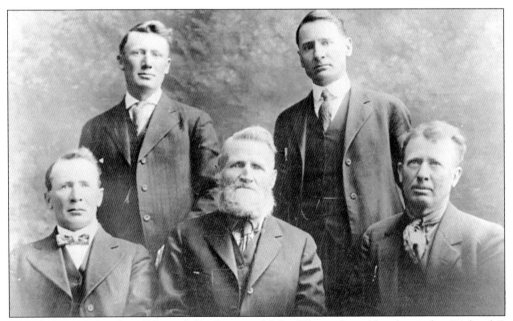

On July 7, 1882, brothers Edmund, Brigham, and John Ellsworth and brother-in-law Richard F. Jardine arrived intending to explore Poole's Island. Since water was too high to cross the Dry Bed Channel, they surveyed the area south of the river. Each staked out their homestead claims for 160 acres, all bordered on the north by the Dry Bed. After registering their claims, they sold their Utah property and returned with their families in September. On August 17, 1884, the settlement became an approved LDS ward and was called "Lewisville" to honor the explorer Meriwether Lewis. This photograph shows Edmund Ellsworth (center) and his sons, from left to right, Frank, Preston, Seth, and Edmund III (Ted). (Courtesy JCHS.)

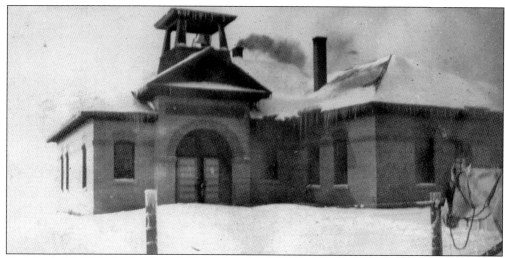

On March 16, 1879, the families of Oliver Cowdery Fisher, Joseph Fisher, and Albert W. Richards settled east of Menan near the smaller buttes. Their first homes were dugouts with tents for roofs. The first public building was a one-room log post office. Jim and Annie Kearney handled the mail. It soon became a community gathering place. When Jim went to Montana to work on the railroad, Annie handled the mail herself. Soon the post office was referred to as "Anna's" or "Annie's." In time, the spelling was changed to "Annis," and the community got its name. This photograph shows the second Annis school, which was built with two rooms in 1912, enlarged in 1923, and used until 1966. (Courtesy JCHS.)

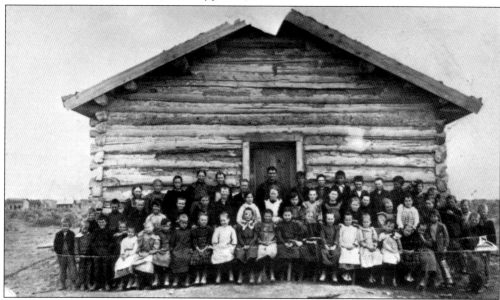

In 1883, William R. Scott and John G. Morgan settled the east end of Poole's Island, 8 miles north of Rigby. In 1886, a separate LDS ward was established with Winslow F. Walker as bishop. Originally called Cleveland for Pres. Grover Cleveland, it was suggested that the name be changed to Winslow to honor Bishop Walker. He objected strongly; when asked what it should be called, he said, "Use the word 'label'." It soon came to be pronounced and spelled "Labelle." By 1890, thirty families resided in Labelle. This photograph shows the combination church-school built in lower Labelle around 1890. (Courtesy JCHS.)

In the fall of 1882, W. W. Parks, W. H. Jones, Peter Allen, and William Berry staked out homesteads east of Lewisville and north of the Dry Bed Channel. The following year, Josiah, Omer, and Cyril Call and George A. Cordon arrived. In August 1885, a branch of the Lewisville Ward was formed and named Rigby to honor William F. Rigby, the first counselor of the Bannock Stake of the LDS Church and employer of some of the early settlers. Pictured around 1910 are W. W. Parks, his daughter Elizabeth Parks Edwards, and two granddaughters, Francis Kite (front left) and Vera Rowland (front right). (Courtesy of JCHS.)

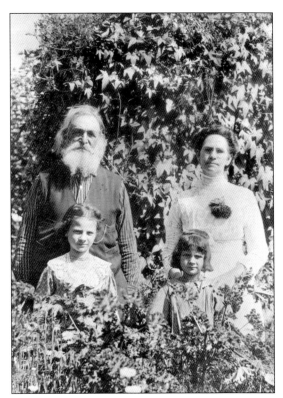

Obadiah Armstrong (1858–1914), a Canadian emigrant and Mormon convert, arrived in the Rigby area in 1888 and established a general store. The building was enlarged to include a post office and living quarters. While visiting family in 1900, his store was robbed. Armstrong had no other recourse but to close the store and return to Canada. He worked for more than five years and raised enough money to return and open a meat market in Rigby in 1907. This photograph shows Obadiah Armstrong and his second wife, Phoebe Jane Wood Armstrong. (Courtesy W. Dale Armstrong.)

The Alfred K. DaBell and James O. Webster families arrived south of Lewisville in 1888. The area was first called Poverty Flats because of the tall sagebrush and lack of trees and water. On August 14, 1892, the Grant LDS ward was established and named for LDS Apostle Heber J. Grant. This photograph shows the white limestone house built by Jeppa Peter Hansen in 1894. It was the first home not built of logs in Grant. (Courtesy Guen Taylor.)

In 1888, Nathan Groom Sr. built a cottonwood log home southwest of Rigby, in the eastern part of Poverty Flats. Others arrived to help dig canals. The area was called Garfield to honor Pres. James Garfield, assassinated in 1881. On September 27, 1908, Garfield LDS Ward was established with Hyrum Severson as bishop. This picture shows Geneva Crossley with the second Garfield school, constructed in 1909. It was a two-story, four-room brick building. (Courtesy Douglas Crossley.)

Camas was established first as a stage station in 1864, and then with the arrival of the Utah and Northern Railroad a depot was established in June 1879. It became an open railroad boomtown, boasting the largest population in the area with a number of hotels, saloons, and stores until the 1890s when the railroad moved its men to Dubois. It experienced a second smaller boom with the surge of dry farming in World War I. In 1961, the post office was closed. None of its original buildings have survived. This undated photograph shows cowboy Charley Muncey in Camas. (Courtesy Mud Lake Historical Society [MLHS].)

David Ririe and his neighbors grew frustrated with difficulties shipping grain to Idaho Falls from eastern Jefferson County. They petitioned the Oregon Short Line Company to build a loop; the railroad was eager to extend its reach, and in 1914, construction began. Until a hotel was constructed, the Riries provided room and board for the 17-member construction crew. The railroad company named the little wooden depot "Ririe." In November 1914, the Vetter and Hewett Corporation platted the village. (Courtesy Ruth Barrus Collection, David O. McKay Library, Brigham Young University-Idaho [BYUI-RB].)

Martin Patrie (1840–1903) has been called "Mr. Market Lake." In the 1880s, Patrie started purchasing land in the Market Lake area, founded its town site, built the Patrie Hotel, and was instrumental in organizing and building the Butte and Market Lake Canal. In the 1890s, he opened the "Homeseekers Paradise," a large tract of farmland for sale, and advertised extensively in Czech magazines and newspapers in the Midwest. Several hundred responded and moved to Market Lake. In 1900, he issued a second call for additional settlers with a German background. His efforts brought 200 new surnames to the area. This 1900 photograph shows Martin Patrie holding his son with an unidentified nurse standing behind. (Courtesy BYUI-RB.)

Homesteading required the land be cleared and the sagebrush removed in most of the Upper Snake River Valley. This photograph shows the "railing" of the brush in the Monteview area in 1911. Iron rails or poles were pulled by two- to four-horse teams to uproot the brush. The brush was then collected into piles and removed. Usually the sagebrush was used for firewood or roof construction. (Courtesy MLHS.)

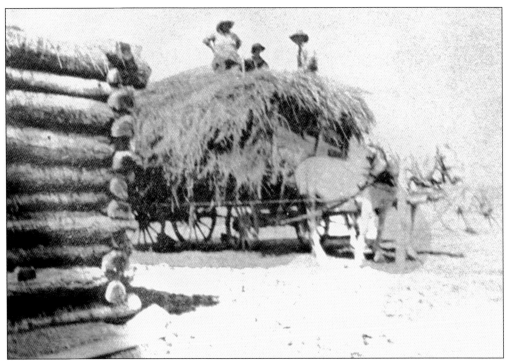
The new buildings constructed by settlers were log structures. This undated photograph shows hay being hauled to thatch the roof of a log home in the Mud Lake area. (Courtesy MLHS.)

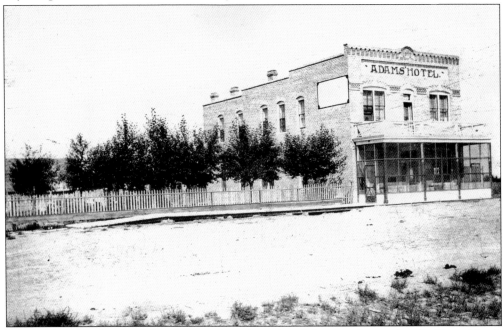
In 1897, Patrie built a brick hotel across from the railroad depot and named it the Patrie Hotel. After Patrie's death in 1903, the Adams family purchased the building from his widow for $2,400, renaming it the Adams Hotel. They operated it until 1909, when it was sold to Frank M. Sheppard for $3,500. It changed ownership in 1910 and again in 1912. (Courtesy Marlene S. Reid.)

The first bridge across the Camas Creek was a simple structure. Poles were laid across the creek and then covered with willows and dirt. This 1911 photograph shows Bertha and Ernest Bauerle's family and visitors standing on the bridge. The Bauerles were some of the first homesteaders in the Mud Lake area in 1907 and filed the first water rights. (Courtesy MLHS.)

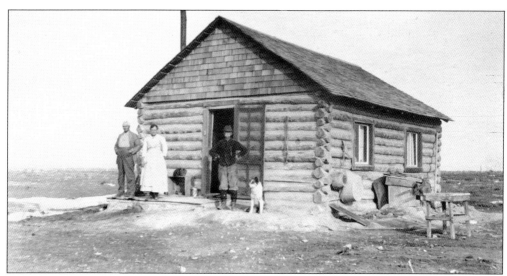

This 1916 photograph shows Ella and Freeman Rising at the homestead of Freeman's brother Charles in the Monteview area. (Courtesy MLHS.)

Three

WATER IS EVERYTHING

The Snake River and its tributaries are the lifeblood of the region. In fact, it serves for 16 miles as the county's eastern border. The Snake River begins in Yellowstone Park in Wyoming. It enters Idaho and is fed by numerous creeks as it runs in a northwesterly direction, until it enters the Snake River Plain just north of Ririe. The river's main channel turns abruptly north and flows by Heise Hot Springs. Another channel (the Dry Bed Channel) continues west and flows in a northwesterly direction north of Rigby, separating the communities of Lewisville and Menan, and then rejoins the Snake River.

Since precipitation is inadequate to grow crops in Jefferson County, irrigation is the essential element for agriculture. The Daughters of the Utah Pioneers' *Pioneer Irrigation—Upper Snake River Valley* records the construction of at least 18 canal systems in Jefferson County and the diversion of the waters of the Snake River. In 1952, water engineer and historian Lynn Crandall wrote that the period from "1884 to 1886 witnessed the beginnings of the constructions on practically all the canals that serve the lands." Many of the canals were dug by the settlers themselves "with old stiff-tongued 'Mormon' scrappers." He noted that the building of the larger canals also "furnished employment and badly needed cash" for the early settlers.

The movement of gravel in the Snake River restricted the water flow in the Dry Bed Channel in 1894, causing a drought for settlers. Between 1894 and 1895, a series of meetings between irrigation companies and farmers decided that it was necessary to build a headgate to control the waters and a canal to carry water from the Snake River to the Dry Bed Channel. Starting in 1894, rocks were shaped and hauled to the site. Work began on the Big Feeder Canal in the spring of 1895, with crews working 11-hour days and six-day weeks. Proclaimed the largest irrigating canal in the United States, it opened its headgates with great fanfare on June 22, 1895. For more than 110 years, it has provided water to irrigate more than 70,000 acres in Jefferson and Bonneville Counties. These efforts were the result of private, cooperative efforts with no government involvement.

Reclaiming the lands in the western part of the county required a different strategy. Waters of the Camas Creek were diverted, wells were drilled, and water was pumped from Mud Lake under the provisions of the Carey Act, passed by the U.S. Congress in 1894 to allow for the construction of state-sponsored reclamation projects.

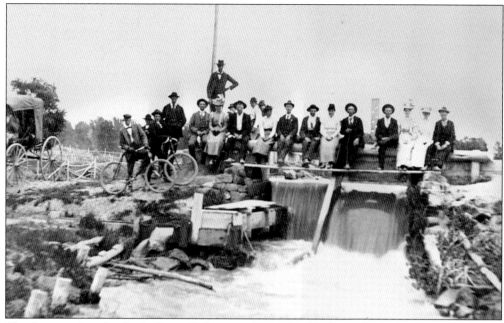

The first canal in the Snake River Valley was the Long Island Canal in Menan. The company was formed by John R. Poole and Alexander N. Stephens with 13 original stockholders. The first decree for irrigation water was filed on June 11, 1880, to divert 2,000 inches of water from the Dry Bed Channel. Brush was removed, canals and ditches dug, and headgates constructed. Workers were paid with company stock. The canal would eventually irrigate 11,000 acres of land. This photograph shows the Long Island Canal south of the mill around 1910. (Courtesy JCHS.)

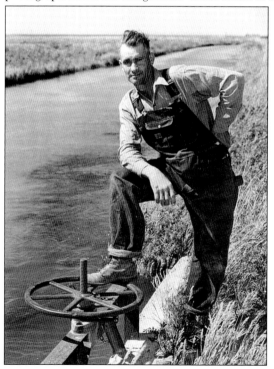

The Utah and Northern Railroad's grade stopped the Snake River's high waters from flowing into Market Lake, opening up a very large tract of fertile land. On June 1, 1884, a decree was filed for 18,435 inches of water from the Snake River for land west and south of Market Lake. Construction of the Butte-Market Lake Canal was very difficult, and blasting was necessary to remove lava rock. It required continual improvements and straightening and has been described as the most expensive ditch in the Upper Snake River Valley. This 1948 photograph shows A. W. (Bill) Stibal, the president of the Butte-Market Lake Canal system (1933–1956). He played an important role in its development and expansion. (Courtesy Marlene S. Reid.)

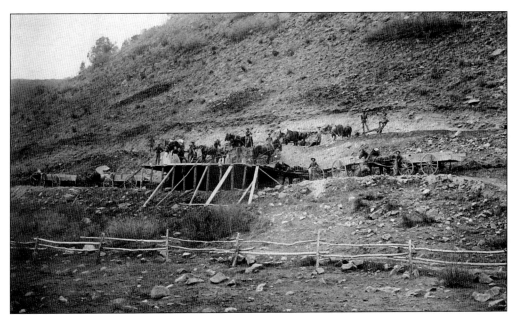

On January 5, 1895, the new Great Feeder Canal Company posted a notice claiming that it would divert 110,000 inches from the Snake River. In the spring of 1895, construction started on the Big Feeder Canal. Twenty-five to thirty-five teams were working at all times excavating the channel. Crews worked on headgates, footings had to be dug, and massive rock structures put in place. They worked 11-hour days and six-day weeks. On Saturday, June 22, 1895, one thousand people celebrated the completion of the Great Feeder Canal. The new structure was dedicated with prayers, recitations, reports, speakers, and music. The *Idaho Falls Times* reported the last speaker, R. L. Bybee, was interrupted after he announced, " 'Ladies and Gentlemen, it gives me great pleasure'. . . . Boom, went the dynamite, tearing away the embankment which held the river from the canal, and with a mighty roar in rushed the foaming stream, before the signal was given." The above photograph shows the beginning of construction on the Great Feeder. Seen below is the celebration just before the waters entered the channel. (Both courtesy JCHS.)

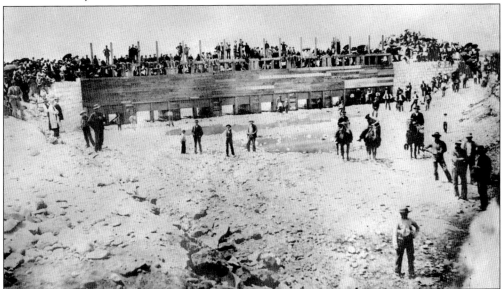

THE GREAT FEEDER CANAL

The Grandest Piece of Irrigation work Ever Accomplished in the west.

Opening Ceremonies of the Headgate witnessed by a Large Crowd.

Last Saturday June the 22d was a day of great rejoicing among the farmers whose lands are watered by the great network of irrigating canals between Idaho Falls and the South Fork of Snake river.

About 22 miles northeast of Idaho Falls and at a point where the South Fork makes a neat turn entering upon its way into the broad and fertile valley a large crowd of honest sons and daughters of the soil assembled to participate in appropriate exercises and to view the grandest piece of irrigation work ever accomplished in the West—The GREAT FEEDER Canal and headgate.

At an early hour the crowd began to assemble, teams and buggies and carts coming from all directions, and by 11 o'clock there were hundreds of people upon the grounds. It was announced that the exercises would begin immediately after dinner. Marckel, the photographer, was present and just before the exercises commenced took a snap shot of the headgate and the crowd near.

R. F. Jardine of Lewisville conducted the exercises, which were opened by song, "Red White and [Blue]" by a selected choir. H. King-

HEADGATE AND CANAL.

The headgate of this canal is supposed to be the largest in the United States. It is 116 feet from end to end and contains 250 cord of stone. It has nine piers, each pier is five feet thick, sixteen feet high, and thirty-two feet at the base. The space between each pier is ten feet. Excavation was made to hard rock, then built up from that. There is a bridge on top. The capacity is 2,500 second feet.

The canal has a hundred foot bottom and is a little less than a mile in length, connecting the main river with the Dry Bed.

hauled on the grounds, excavation for the headgate begun, and the team of the farmers called out, and money was raised by assessments being levied on stock. There were some grumblers as there usually is in any kind of an enterprise, but they were relegated to the rear, and the management in charge pushed the work vigorously forward employing as large a force as could be obtained, and the result was the completion of the work as it now stands—the grandest piece of irrigation work in the West, at a cost of serveral thousand dollars, by which over one hundred thousand acres of land can be reached and irrigated.

Among those prominent in the enterprise are Joseph A. Clark, W. S. Chaney, J. O. Webster, Eli McIntire, Josiah Call, J. R. Jones, Mr. Yargensen, J. P. Davis, R. F. Jardine and others. Mr. Clark has had charge of the management of the construction and the work will stand as a monument to his skill and ability as a civil engineer.

CANALS INTERESTED.

Following are the principal canals interested in the Great Feeder:

IDAHO FALLS CANAL & IRRIGATION CO.

The Idaho Falls Canal & Irrigation Co., one of the principal companies interested in this enterprise, takes its water out at a point about four miles

THE GREAT FEEDER HEADGATE AND CANAL.

This photograph shows a portion of the front page of the *Idaho Falls Times* (June 27, 1895) describing the dedication of the Big Feeder Canal and proclaiming it to be the "grandest piece of irrigation work ever accomplished." (Courtesy *Post-Register*.)

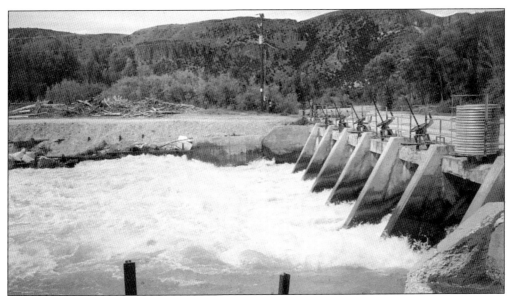

This photograph shows the Big Feeder in 2000. (Courtesy *Post-Register*.)

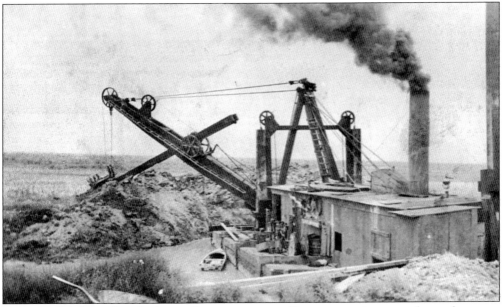

Mud Lake has been described as an "intermittent pond" never covering more than a few acres. Historically it has varied greatly in size and shape. It became nonexistent after the droughts of the 1880s. It began to grow again as irrigation started on the Egin Bench, a terrace southwest of St. Anthony, in 1895. About 1900, settlers began noticing water standing in pools about a mile north of Hamer. From 1899 to 1908, the lake rose 5 feet. A 1914 survey showed a water surface of approximately 14,200 acres. Three Carey Act projects were proposed for the Mud Lake basin. Only one succeeded. On April 13, 1909, William Owsley proposed the segregation of 21,760 acres for the diversion of the waters of Camas Creek, the construction of a gravity canal, and two pumping stations. On June 18, 1909, the Owsley Canal and Irrigation Company was incorporated to undertake the construction of the project. The photograph shows a floating dredge digging the first channel around 1915. (Courtesy MLHS.)

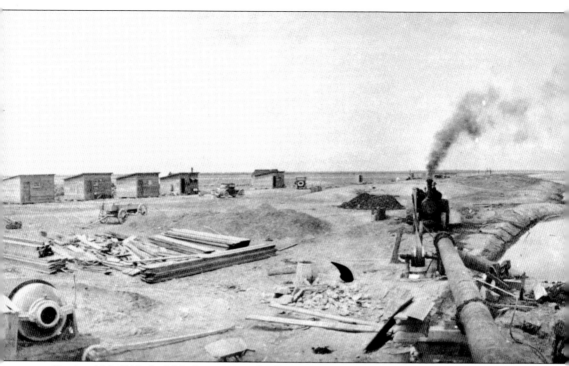

On April 20, 1910, the U.S. General Land Office approved the land segregation for the First Owsley Project, and on October 21, the Owsley Carey Land and Irrigation Company contracted with the State of Idaho to build the necessary irrigation works. On April 3, 1914, the Idaho State Land Board authorized the opening of project lands and the sale of water rights. In 1918, the project was declared completed, and its operation was transferred to the Owsley Canal Company. The

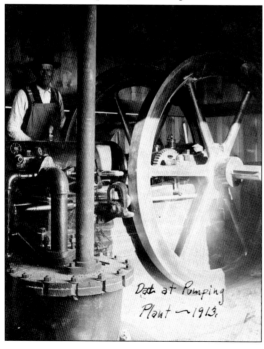

This 1913 photograph shows Viers Peterson (1889–1970) inside of the Owsley Canal pumping plant. (Courtesy MLHS.)

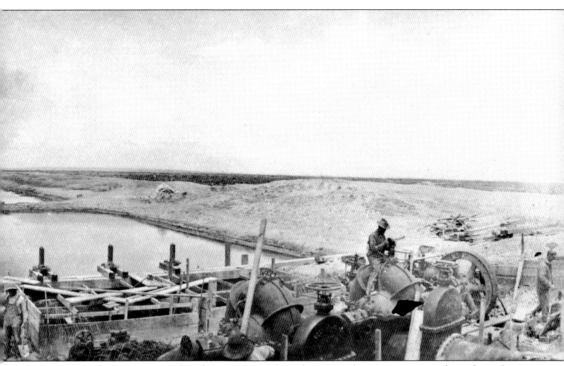

project consisted of a main canal with a pumping plant diverting the water into two large laterals. This photograph shows that some water was made available on May 1, 1916, by the temporary installation of a 15-inch centrifugal pump with a capacity of 15 second-feet and operated by a 75-horsepower steam engine. (Courtesy Idaho Department of Water Resources.)

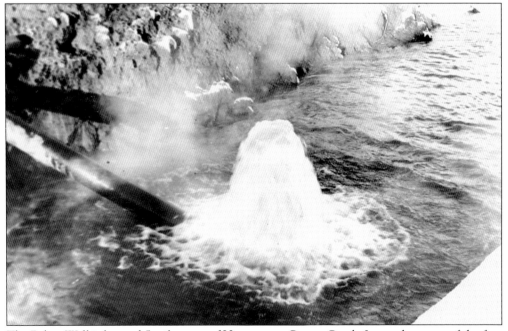

The Bybee Well is located 5 miles west of Hamer near Camas Creek. It was the scene of the first Owsley artesian wells. (Courtesy MLHS.)

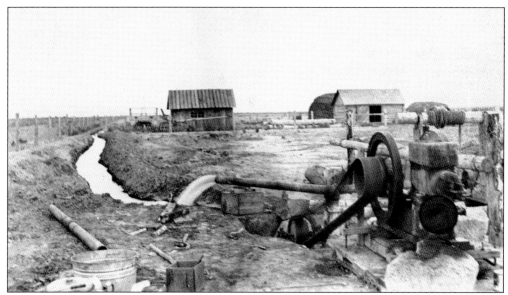
John Shavadahl made his first attempt at an irrigation well in Monteview in 1911. Instead of drilling, the well was blasted though the rock with explosives. (Courtesy MLHS.)

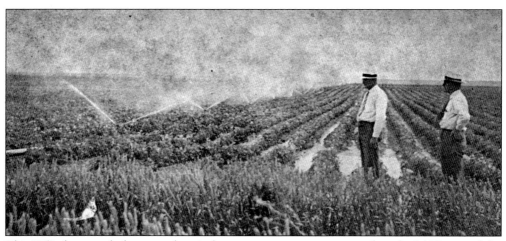
This 1952 photograph shows an electrical spraying irrigation system used on the 1,100 acres of the Ray McCarty farm south of Roberts. Sprinkling irrigation has transformed agriculture, expanding cultivation to areas not accessible to ditches or canals. (Courtesy *Post-Register*.)

Four

ONE COUNTY, TWO COUNTY, THREE COUNTY, FOUR . . .

On March 3, 1863, Idaho Territory was created and included the future states of Idaho, Montana, and Wyoming. Its population of 32,342 (21,116 within the boundaries of the future state of Idaho) was scattered in mining camps, trading posts, a few settlements in the Boise area, and near the Utah border.

As settlers moved into the new territory, counties were created; existing counties were divided and then divided again. A family residing in the Lewisville area between 1880 and 1915 would have lived in four different counties.

In 1864, Oneida County was organized extending north 180 miles from the Utah border and 108 miles west from the Wyoming border. Oxford City was its first county seat, then Soda Springs, and finally Malad. Its first census reported 3,730 residents within its boundaries.

Bingham County was created out of Oneida County in 1885 with Blackfoot as its county seat. It encompassed most of southeastern Idaho. As the population grew, Blackfoot seemed too far to travel for business, and in less than a decade, the county was again divided. On March 8, 1893, Fremont County was created from the northern portion of Bingham County. St. Anthony was made the county seat. This new county became the largest in the state of Idaho.

On February 28, 1913, the Idaho State Legislature passed House Bill 125, and it was quickly signed by Gov. John M. Haines. Chapter 25 allowed for the creation of Jefferson County out of Fremont County and provided for a special election to either approve or defeat the action. Menan, Rigby, and Roberts were proposed as the new county seat. The new county was overwhelmingly approved (1,825 for to 587 against), and Rigby was chosen the county seat.

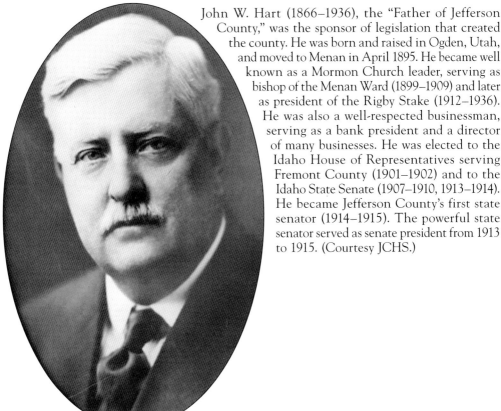

John W. Hart (1866–1936), the "Father of Jefferson County," was the sponsor of legislation that created the county. He was born and raised in Ogden, Utah, and moved to Menan in April 1895. He became well known as a Mormon Church leader, serving as bishop of the Menan Ward (1899–1909) and later as president of the Rigby Stake (1912–1936). He was also a well-respected businessman, serving as a bank president and a director of many businesses. He was elected to the Idaho House of Representatives serving Fremont County (1901–1902) and to the Idaho State Senate (1907–1910, 1913–1914). He became Jefferson County's first state senator (1914–1915). The powerful state senator served as senate president from 1913 to 1915. (Courtesy JCHS.)

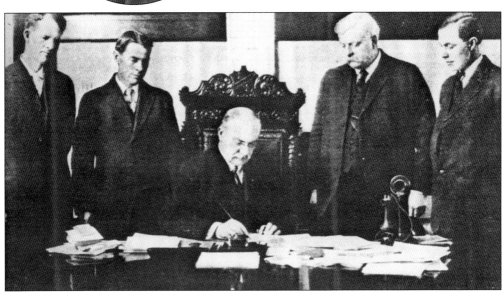

Idaho governor John W. Haines signs the bill that created Jefferson and Madison Counties. Pictured with him from left to right are Representative Robert Gilchrist (Fremont County), Representative Ralph S. Hunt (Fremont County), Sen. John W. Hart, and Representative Lloyd Adams (Lincoln County). (Courtesy JCHS.)

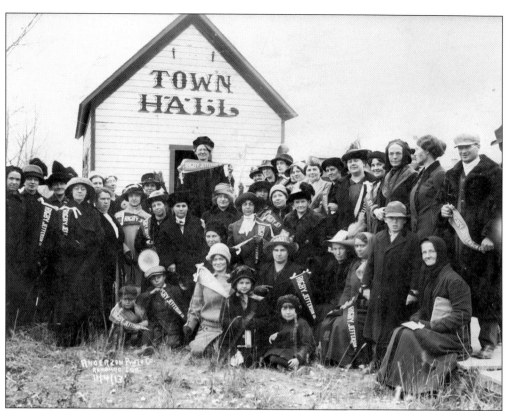

Three communities were nominated to serve as county seat: Menan, Rigby, and Roberts. While each had its own lobbying strategy, Rigby appeared to have the most comprehensive, with representatives visiting each community in the proposed county. They promised to provide a courthouse at no cost to county taxpayers. In October, the *Rigby Star* endorsed the creation of Jefferson County and supported Rigby as county seat. Pictured above is a rally of Rigby supporters in October 1913. At right is a poster supporting Menan as county seat. (Both courtesy JCHS.)

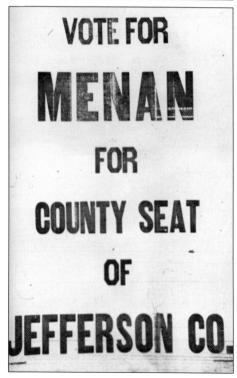

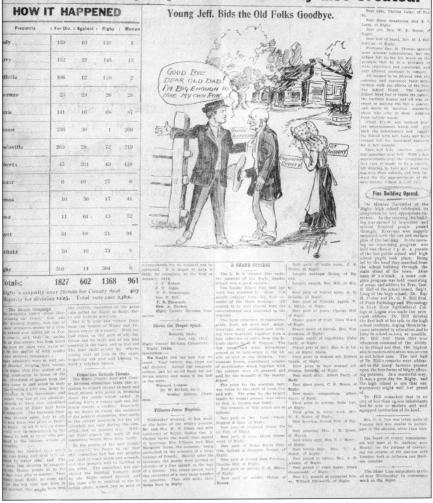

On November 6, the *Rigby Star* proclaimed the results of the election. The creation of Jefferson County was overwhelmingly confirmed by voters, and Rigby was selected as county seat. Interestingly, five precincts (Camas, Grant, Hamer, Lorenzo, and Roberts) voted against division and the creation of Jefferson County. The minority of voters in Grant and Roberts wanting the division supported Menan as county seat, while voters overwhelmingly supported the division in Lewisville and Menan and wanted Menan as county seat. (Courtesy *Post-Register* and Brigham Young University–Idaho.)

Work commenced on the new Jefferson County Courthouse on December 1, 1913. The old schoolhouse was purchased and moved directly in front of the Rigby town hall building. The citizens of Rigby paid for the structure and all of the improvements. When completed, the building contained a full-sized courtroom and offices for auditor, treasurer, probate judge, assessor, and superintendent of schools. The building was officially presented to the county's new officials on January 15, 1914. It served as courthouse until 1939. (Courtesy JCHS.)

Jefferson County's first officials were appointed by Governor Haines to serve until elections could be held in the fall. On January 5, 1914, the new officials met for the first time. They were E. J. Harrop, sheriff; A. S. Anderson, treasurer; Bash L. Bennett, assessor; William E. Selck Sr., probate judge; William S. Burton, superintendent of public instruction; H. L. Hoopes, auditor; and William P. Hemminger, county attorney. The new county commissioners were George A. Cordon, C. A. Smith, and Charles A. Harwood. Rigby precinct justice of the peace J. W. Jones swore in Hoopes, and he in turn swore in the remaining officials. (Courtesy JCHS.)

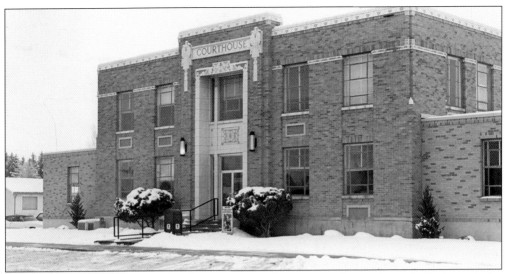

In 1939, Jefferson County completed construction of a new courthouse. It was built through the passage of a $35,000 bond and a WPA grant of $21,273. The City of Rigby had deeded 20 lots to the county for its construction. Work had begun in 1937 with Johnson and Mickelson from Logan as contractors. The courthouse served Jefferson County until 2007. It was placed on the National Register of Historical Buildings in 1987. (Courtesy JCHS.)

A new, modern Jefferson County Courthouse opened on May 2, 2007. It boasts a new jail with a capacity for 134 prisoners. (Courtesy PLS.)

Five

BOOM, BUST, AND DEPRESSION
1900–1940

The four decades between 1900 and 1940 contain some of the best of times and worst of times for Jefferson County. The period from 1900 to 1919 was one of hope, optimism, growth, and change. It was a time when communities were organized, town sites surveyed, railroad lines extended, and businesses established. The original log homes were replaced with rock and brick structures. Easily farmed lands were already occupied, and new settlers began moving to the more challenging arid lands in the western part of the county. Hamer, Mud Lake, and Terreton were settled. Some communities gained momentum, while others began to fade.

Farmers responded to Pres. Woodrow Wilson's call for increased agricultural production to meet the needs of World War I. With the war's end, federal price supports were removed from all agricultural products. With widespread overproduction, prices plummeted and markets shrank. By 1921, a severe agricultural depression had settled in. By 1922, the value of Idaho farmland had fallen by one-third. Prices were startling: potatoes had fallen from $1.51 in 1919 to 23¢ in 1922, hay from $22 a ton to below $10, and wheat from $2.05 to 72¢. Banks began to fail when farmers and ranchers were unable to meet their financial obligations. Twenty-seven Idaho banks collapsed in the early 1920s. All Jefferson County banks closed their doors but one. Population for the first time stopped growing and fell by more than eight percent. However, by 1925, the depression eased, and recovery began.

Ironically the economic upturn came just in time to collide with the Great Depression, which began in 1929 and soon spread into Idaho. Farm prices plunged to new lows, with the total value of crops falling by almost 50 percent from 1931 to 1932. Responding to the shriveling tax base, government budgets were cut, and a number of businesses failed. The WPA sponsored several projects in Jefferson County to put citizens to work while improving the county's infrastructure. By 1940, prosperity and optimism was beginning to return.

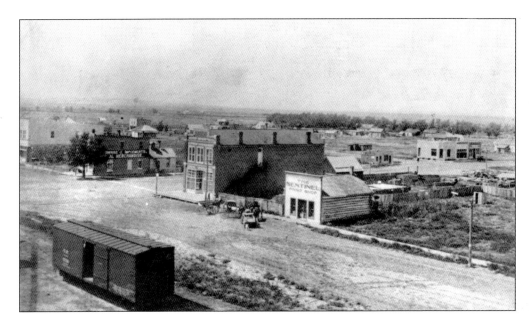

In 1910, Market Lake incorporated and changed its name to Roberts to honor Harry Ashton Roberts, the division engineer and assistant superintendent of the Oregon Short Line in Pocatello, in an attempt to either have railroad shops relocated to the community or receive his assistance. Neither occurred, and he sold his local land holdings. William Whitlack served as the town's first mayor. Its population was 395 in 1910. Roberts boasted a number of businesses, including a cheese factory, a flour mill, an ice factory, a cigar factory, various livery firms, two banks, a newspaper, three different churches, and schools. The 1905 bird's-eye view above appears to have been taken from the railroad water tank. It shows a southwest view of Roberts, and across the street is the *Roberts Sentinel*. The newspaper was founded in 1889 and was published for a number of years. Below is a 1919 view looking directly west across the railroad tracks toward the high school. (Above, courtesy JCHS; below, USRVHS.)

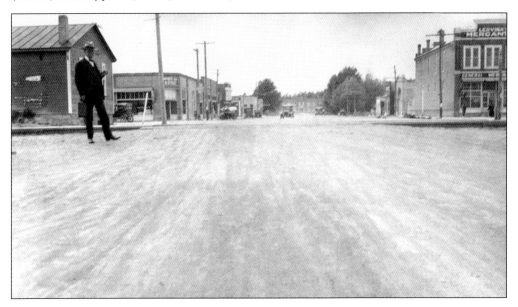

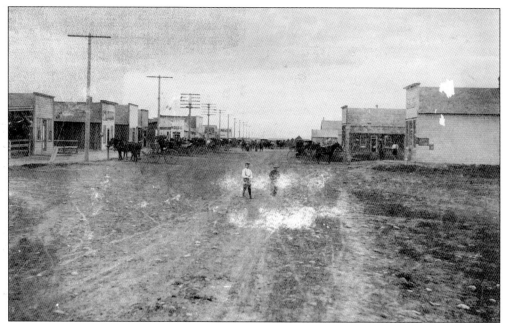

In 1890, Andrew Jenson described Rigby as being "nearly unoccupied" and "a vast sagebrush plain." The situation changed with the arrival of the Yellowstone Branch railroad in 1900. When Lewisville and Menan feared the railroad's influence and rejected the attempt to have the line pass through their communities, the smaller Rigby stepped forward and provided financial incentives. The railroad caused much change—notably, Rigby's population increased from 555 in 1910 to 1,000 in 1915 and 1,629 in 1920. Rigby was incorporated as a village in 1904 and a city in 1915. The photograph above shows Rigby's Main Street looking west from the railroad tracks in 1903. Below is Rigby's Main Street in 1919 looking east. The large Quality Store is on the left. (Both courtesy JCHS.)

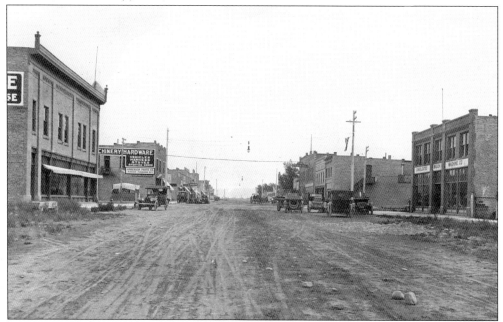

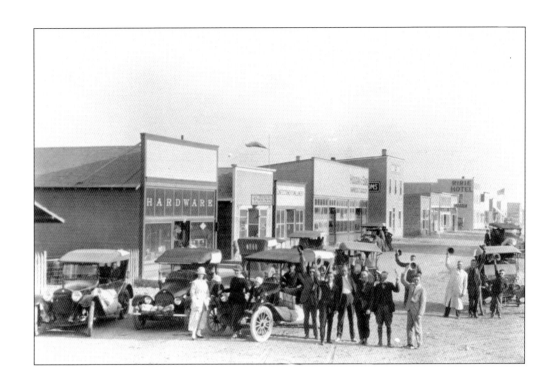

Less than five years after Ririe's town site was surveyed, the promotional photograph above shows Ririe's Main Street looking north in 1918. In 1919, a fire destroyed much of Ririe's east side business district. Below is a northeast view of the intersection of Main and Hewitt Streets in Ririe in 1921. Mary Aowiki built the Ririe Hotel shortly after her arrival in Ririe in 1915. She operated it until her death in 1957. It was razed in 1966. (Above, courtesy JCHS; below, USRVHS.)

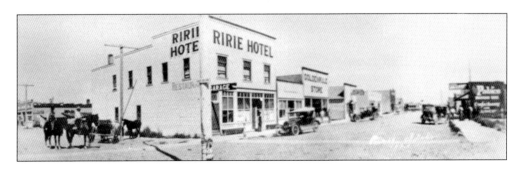

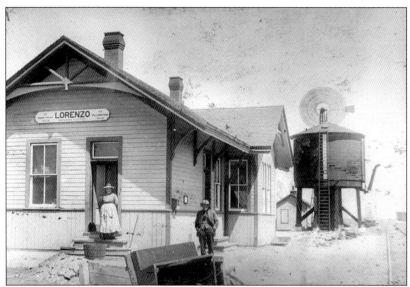

Located on the Jefferson–Madison County line, Lorenzo was founded in 1900, when the railroad arrived. It was named for LDS Church president Lorenzo Snow. The photograph above shows Lorenzo's railroad depot around 1910. It was built in 1905 as a small one-story structure with a gravel platform. In 1908, a bunkhouse, tool house, pump house, and watering station were added. The passenger station was never very busy and closed in March 1917. The watering station was used until 1951. The Harrop brothers (Aaron, Ed, and Sam) and John Holland established the Harrop Brothers and Holland store and donated land for a town site. In 1901, Albert Beazer and William Galbraith purchased the Harrop store and renamed it Albert Beazer General Merchandise. Beazer operated the store until he sold it to George Hoggan in 1924. It was destroyed by fire on June 16, 1930. (Both courtesy JCHS.)

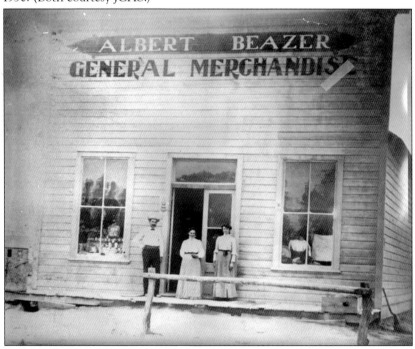

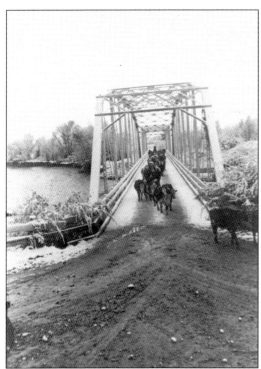

The Snake River was a treacherous barrier to travelers. Four bridges have spanned the river at Lorenzo. The first (1896–1910) was a wooden wagon and road bridge. Maintenance costs were high, as individual spans were washed out and had to be replaced. The second (1910–1936) was a steel highway bridge. The third (1936–1979) was a three-span bridge, the second-longest bridge in Idaho (696 feet). Two modern concrete bridges opened on November 4, 1980; this picture shows the herding of cattle over the Lorenzo's second bridge around 1920. (Courtesy USRVHS.)

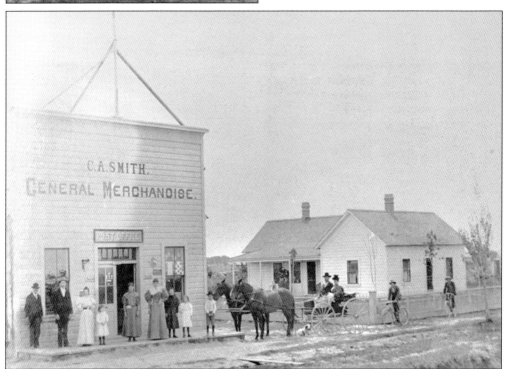

Charles A. Smith built a general store in Menan in 1885 and operated it until 1890, when his son and daughter-in-law Charles A. Smith Jr. and Ida Poole Smith managed it. The Smith family operated it until it was sold to J. L. Hayes in 1922. (Courtesy JCHS.)

The Grant Store was the gathering place for local residents. It was built on Frederick Hansen's land and was first owned by Alfred Bramwell. It was operated by various individuals and families for more than 80 years. Joseph L. Gardner and his family operated the store from 1908 to 1930. This photograph shows Claude and Lottie Waters, the stores operators, in 1926. (Courtesy Guen Taylor.)

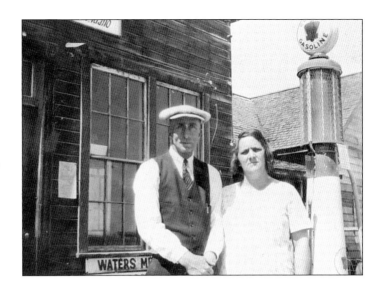

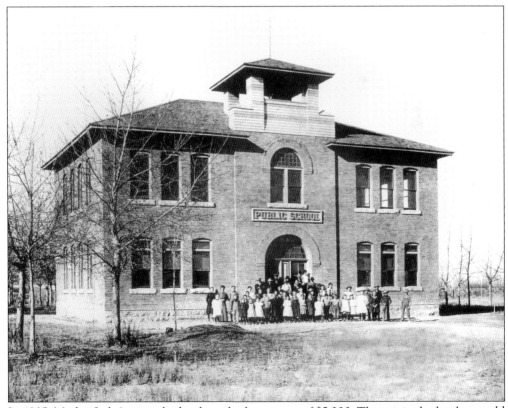

In 1905, Market Lake's second school was built at a cost of $5,000. The original school was sold to a group of Baptists to be used for church services. This photograph shows the school in 1906. The teachers listed were Lillian Field and Kathrine Burgraff. (Courtesy Marlene S. Reid.)

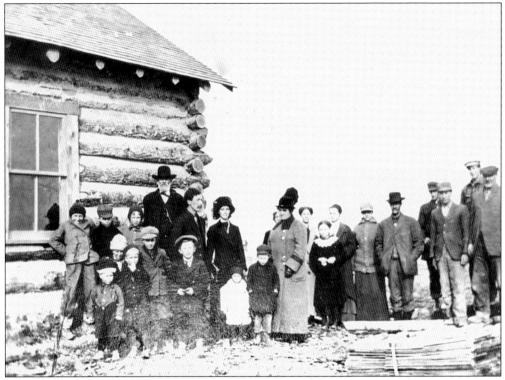

In 1914, a log building was constructed to serve as the Monteview School and Church House. This picture shows all the people that helped to build it. The school was constructed in thriving times. When water shortages forced many settlers to leave, the log school was abandoned in the 1930s. (Courtesy MLHS.)

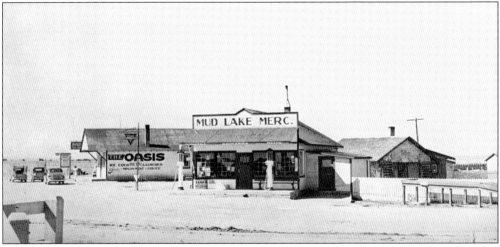

The first permanent settlers in Mud Lake were Horace R. Jackett and his son Frank in 1901. They were attracted to Mud Lake by the appearance of springs and ponds of water on previously dry sagebrush land. Others soon followed, and in 1918, the Owsley project was completed, bringing other settlers to the area. In the 1930s, Pete Kuharskis established the Mud Lake Merc, Oasis Bar and Café, and a car service station in Mud Lake. The photograph shows the Mud Lake Merc with the Monreau Speelmon house behind it in 1937. (Courtesy MLHS.)

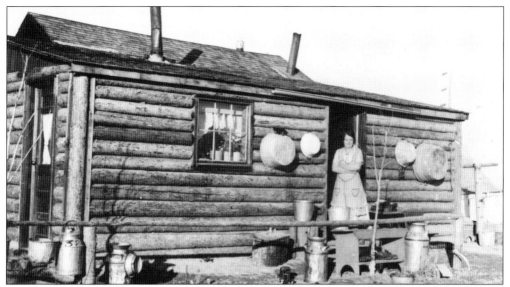

George and Maud Hansen arrived in Hamer in the spring of 1933. She was disappointed to find few trees, poor roads, plenty of jackrabbits, and sagebrush. He worked hard digging ditches, grubbing sagebrush, farming, and raising cows and chickens. This photograph shows Maud Hansen standing in front of their home. (Courtesy Melvin J. Hansen.)

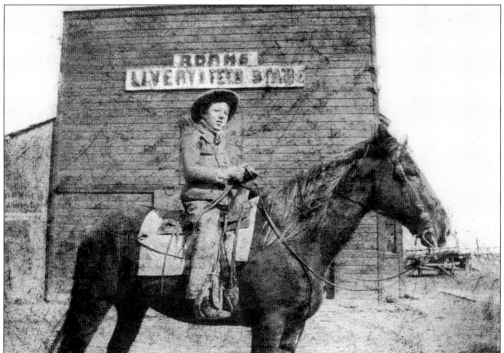

This 1906 photograph shows Willard Adams in front of his father's (Newt Adams) livery stable in Market Lake. In 1908, Adams moved his family to Rigby and leased the Sayer and Sons Livery Stable with the option to buy. He purchased it the following year and sold their hotel and livery business in Market Lake, making Rigby the outfitting center for communities on the east side of the county. (Courtesy Marlene S. Reid.)

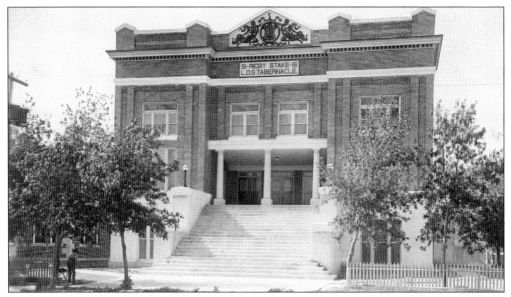

On April 6, 1916, construction began on the new Rigby LDS Church Stake Tabernacle. Thousands of volunteer hours were donated. On Sunday afternoon, September 9, 1917, LDS Church president Joseph F. Smith gave the dedicatory prayer before 3,000 attendees. For more than 60 years, the tabernacle served both church and community needs. This photograph shows the original building around 1923. In 1950, extensive remodeling removed the exterior stairs and added offices and a lobby with interior stairs. (Courtesy JCHS.)

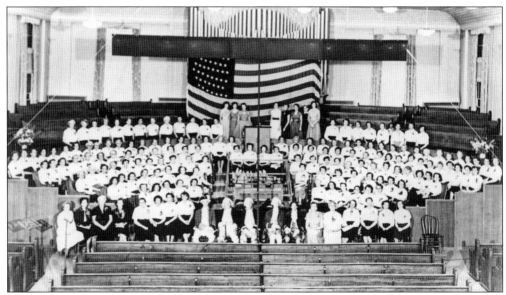

This image shows the Rigby and East Rigby LDS Stake Relief Society Choruses in the Voice of the People program on July 4, 1954, in the tabernacle's impressive assembly hall with its beautiful pipe organ. (Courtesy BYUI-RB.)

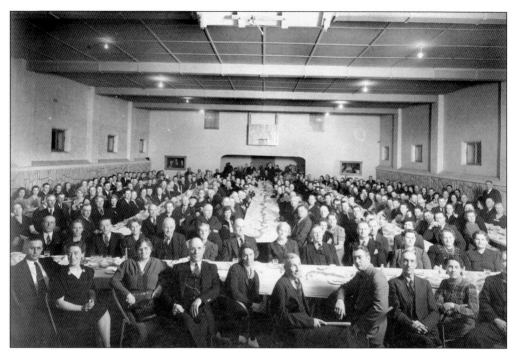

The tabernacle's large basement was dug with horse-drawn scrapers. A hardwood floor was added and included both a large kitchen and a baptismal fount. This image shows the Menan LDS Ward Banquet in 1931. Banquets of more than 1,000 people could easily be served. (Courtesy JCHS.)

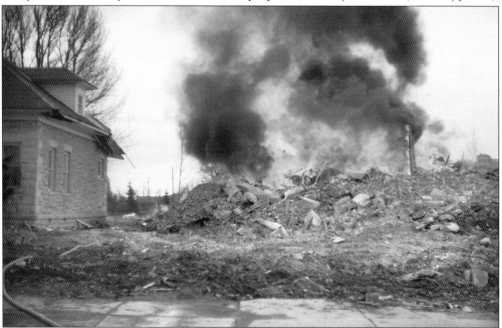

The Rigby and East Rigby LDS Stakes decided to demolish the tabernacle and replace it with two modern stake centers. They believed that it was better to build than to remodel and that the new structure would better meet the stakes' needs and requirements. In February 1970, the tabernacle was razed. This photograph shows the fire that destroyed what remained. (Courtesy George Marriott.)

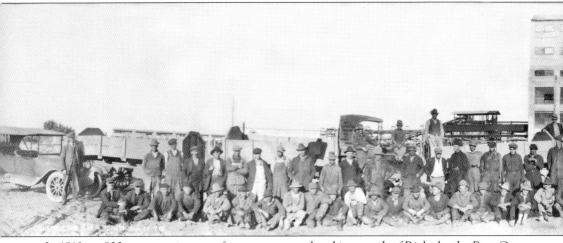

In 1919, an 800-ton capacity sugar factory was completed just north of Rigby by the Beet Growers Association, a farmer's cooperative with 2,700 stockholders. During its first year of operation, it processed 18,000 tons of sugar beets. Because of inadequate acreage and disastrous sugar prices following World War I, the company went bankrupt in 1921. Two years later, the $1.2-million factory was purchased by the Utah-Idaho Company for $800,000. The factory was operated in 1924 and produced 20,971 tons of sugar but closed from 1925 to 1929 because of inadequate

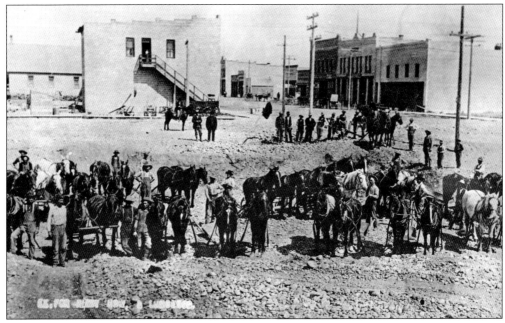

In 1909, the Rigby Hardware Store and Lumber Company built a modern department store on the corner of Main and State Streets in Rigby. It measured 85 feet by 125 feet and carried large stocks of appliances, clothing, coal, dry goods, hardware, household goods, and tools. The store had two entrances—a corner door and an east entrance. Its second story housed professional offices for attorneys, dentists, and doctors. It was considered to be the largest department store in Eastern Idaho. The photograph shows the construction of its foundation. (Courtesy JCHS.)

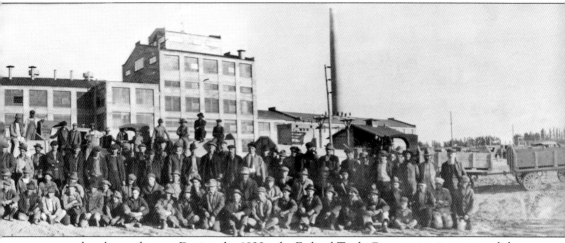

acreage and curly top disease. During the 1920s, the Federal Trade Commission investigated the Utah-Idaho Sugar Company's monopolistic practices concerning the bankruptcy of the Rigby factory. Many hearings were held, but no action was taken. In 1930, the factory operated briefly, and 63,630 bags of sugar were produced. It remained inactive until 1939, when it was dismantled and converted into a large sugar storehouse. (Courtesy JCHS.)

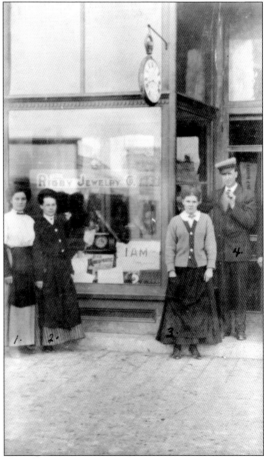

In 1902, Cyril and Josiah Call hauled rock all winter to build the Call Block on Main Street in Rigby. It was the first brick building in Rigby and the second business building on Main Street. It was known as Bowers and Schwitzer Company and was rented to the Golden Rule Store for $35 a month. In October 1925, the Golden Rule store failed and closed after a six-month sale of all goods. J.C. Penney operated from the building for more than 35 years, closing in 1975. In 1987, the Call Block burned to the ground. Ida Marie Call Smith stands in front of the Golden Rule Store around 1915. (Courtesy JCHS.)

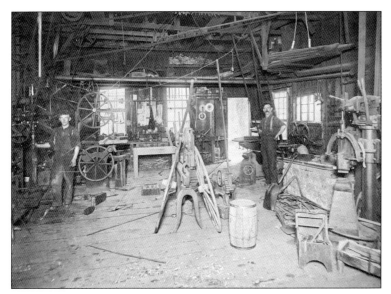

Henry George Marriott owned the Roberts Blacksmith Shop. The shop was located east of the railroad tracks with the Roberts slough to its back. Marriott (at right, with mustache) is pictured with his son-in-law Roy Mounteer in 1918. (Courtesy George Marriott.)

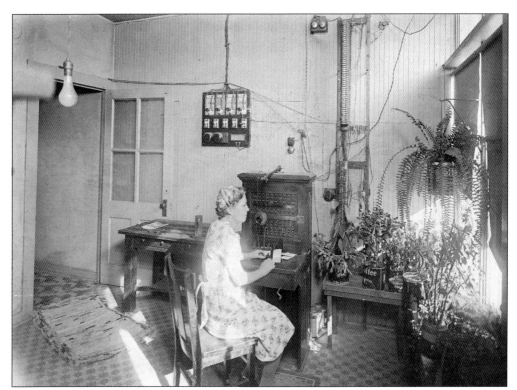

Maude Marriott Mounteer operated the Roberts telephone exchange office in her home for 20 years. The front faced east. There were 20 to 30 telephones in the system. The operator had to place each call by plugging a cable into the switchboard. An isolation booth was located on the left to make long-distance calls. The hall connected the Mounteers' living quarters. The exchange was originally owned by her father, Henry George Marriott, around 1920. (Courtesy George Marriott.)

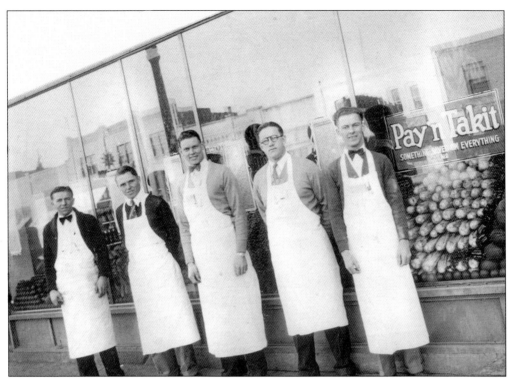

The Pay'n Takit Store was an experimental store opened in Rigby about 1928. It was established to test a new concept that arranged groceries so shoppers could select their own items to bring to the cashier rather than having clerks retrieve items. This store provided an operational test before the stores opened elsewhere as Safeway. It was located in the Call Building next to J.C. Penney on Rigby's Main Street. Safeway operated a store in Rigby for almost 30 years (1941–1970). In this photograph from left to right are Clifford Riley, R. W. "Bob" Purrington, Joseph Rytting, and two unidentified clerks. (Courtesy JCHS.)

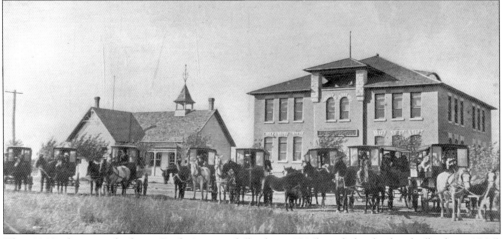

This 1909 photograph shows Rigby's second (built in 1896) and third schools (built in 1906) and the school wagons used to transport students to and from school. It was used to advertise the area's growth and to promote settlement. It was published in at least two Utah newspapers. (Courtesy JCHS.)

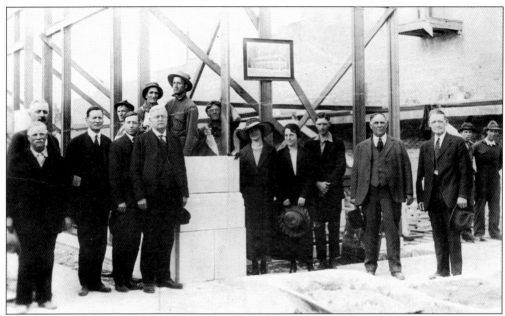

On October 23, 1920, the First National Bank of Rigby opened for business in its new home on the northeast corner of Main and State Streets. It became the only bank in Rigby after purchasing the Anderson Brothers' Bank of Rigby in 1921 and the Jefferson County Banks of Menan and Rigby in 1923. On January 9, 1925, the First National Bank of Rigby closed permanently. Bank president John W. Hart explained the reasons for its failure included the bank acquisitions, the construction of a new bank building at a cost of $72,000, the loaning of large sums with insufficient securities, and a run on the bank that caused the withdrawal of $200,000. For six months, Rigby had no bank. The photograph above shows the laying of the bank's cornerstone on May 8, 1920, with bank officials, employees, stockholders, and workmen. Bank president John W. Hart stands in the center next to the cornerstone. The completed building is shown below. (Both courtesy JCHS.)

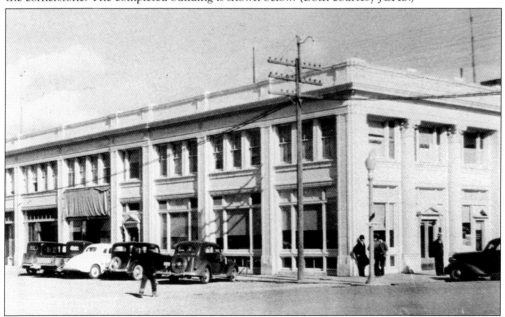

During the 1890s, the Bank of Market Lake (later Bank of Roberts) was the first bank founded in Jefferson County. In 1919, a second bank, the First National Bank of Roberts, was established. William Stibal Sr. acquired controlling interest in both banks and merged them to become the First Bank of Roberts. It was the only bank in Jefferson County to remain open during the agricultural depression. In June 1925, it moved to Rigby and was renamed the Rigby National Bank. It opened for business on July 2 with a capital of $40,000. This undated photograph shows the Robert's bank building after the bank had moved to Rigby. (Courtesy USRVHS.)

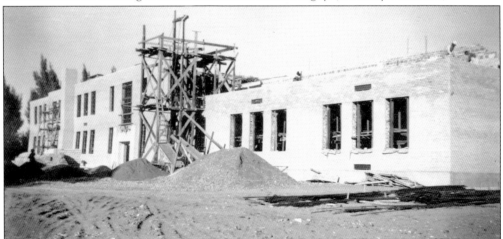

On November 10, 1938, work started on a new Rigby Elementary School. Fifty percent of funding was paid through the WPA and the rest through the sale of school bonds. The building was dedicated on February 28, 1941, and served the community for more than 60 years. It was razed in 2006. (Courtesy Bartley Stowell.)

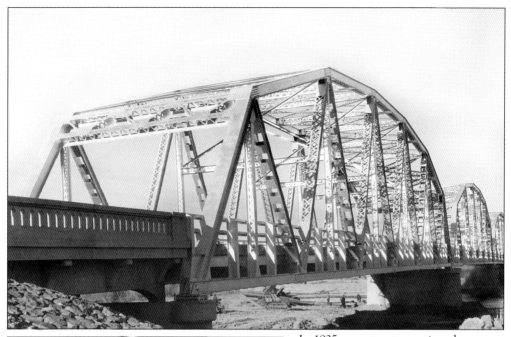

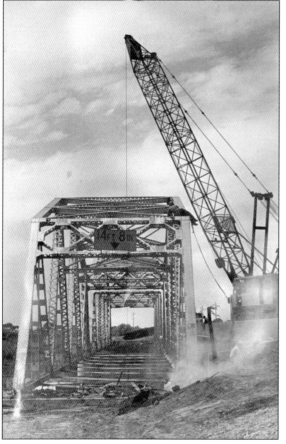

In 1935, a contract was given by Jefferson and Madison Counties for construction of a new Lorenzo Bridge across the Snake River. Completed in November 1936, this three-span, silver painted bridge silver was constructed at a cost of $191,814 and was reported to be the second-longest bridge in Idaho (696 feet). It was replaced by two concrete bridges on November 8, 1980. After three months, the spans were dropped one by one and hauled away for scrap on November 4, 1980. (Both courtesy JCHS.)

Six

AGRICULTURE, BUSINESS, AND INDUSTRY

Jefferson County is one of Idaho's most agricultural counties. The county's soils and climate are suitable for many crops. The issues of a short growing season and water and wind erosion had to be recognized. Farmers grow alfalfa, barley, hay, oats, potatoes, and wheat, raise cattle, sheep, and horses, and produce milk and eggs. However, specific crops have changed through time to meet market demands. The first potato warehouse was built in Lewisville in 1913. Sugar beets were grown for more than 70 years until the sugar industry collapsed in Idaho after the closure of the U and I Sugar Company in the 1970s. Today major crops include potatoes and various grains. In 1990, Idaho's statehood centennial celebration recognized centennial farms, which are farms that have been operated by the same family for at least a century. Jefferson County recognized fourteen such farms.

Its largest industries relate to food production. Ball Brothers was founded in Lewisville in 1942, Idahoan Foods in Lewisville in 1960, Larsen Farms in Hamer in the 1970s, and Rigby Products in Rigby in the 1960s.

Numerous businesses have operated in Jefferson County. The county's oldest businesses include the Jefferson Star (founded in 1903), Broulim's Grocery Store (founded in 1922), and Eckersell's Funeral Home (founded in 1928). While some businesses operated for decades and then closed, others existed for only a few short years. Each contributed to the growth of their community and is remembered in history.

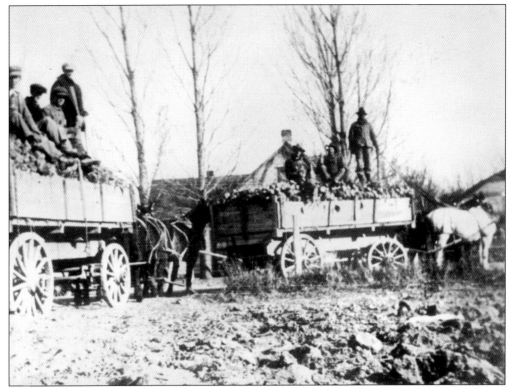

The sugar beet industry came to the valley in the early 1900s. The crop demanded hours of hand labor, as they had to be thinned and weeded many times. They then had to be topped, loaded on wagons, and delivered to a local dump. This photograph shows wagons full of sugar beets in Lorenzo in 1910. Pictured are P. R., Oscar, and Robert Geisler (wagon to the left), Earl Lewis, and Ira "Ike" Hall (standing, wagon to the right). (Courtesy JCHS.)

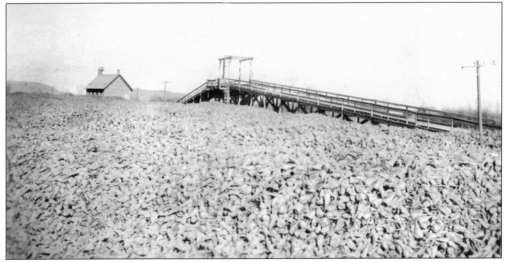

Beet dumps were established in several locations, including Annis, Menan, and Lewisville adjacent to railroad lines. This undated photograph shows the Lewisville dump with 5,000 tons of sugar beets. (Courtesy JCHS.)

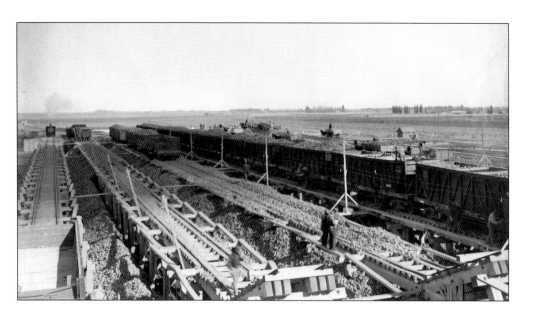

In 1903, this large sugar factory was built in Lincoln just east of Idaho Falls. Farmers transported their sugar beets by wagons of trains throughout the Upper Snake River Valley. Both pictures were taken in 1909 by an official photographer of the Oregon Short Line Railroad Company for advertising purposes. (Both courtesy Bonneville County Historical Society—Museum of Idaho.)

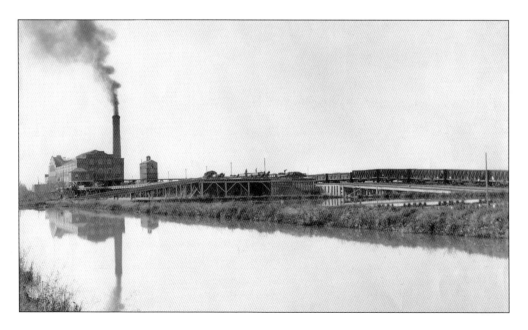

Potatoes have been a major crop in Jefferson County for more than a century. The first potatoes were shipped from Rigby in 1901. Historically they were harvested in late September or early October, after a frost killed the potato vines. They would be dug, handpicked, placed in bushel baskets, dumped into a potato sack (there were two bushel baskets per sack), stood in a row, and then picked up and stacked on a wagon or truck. They would then be stored in a potato cellar or transported to a local potato plant. The photograph above shows irrigated potatoes on O. Dale Randall's five-generation centennial farm in the 1960s, and below are potato pickers on the Joe Field farm in Grant in 1929. Pictured from left to right are Jay Webster, William Ashment, Fay Ashment, Art Boyce, and Golden Boyce. (Both courtesy Guen Taylor.)

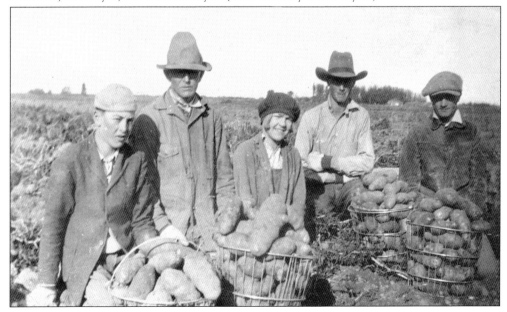

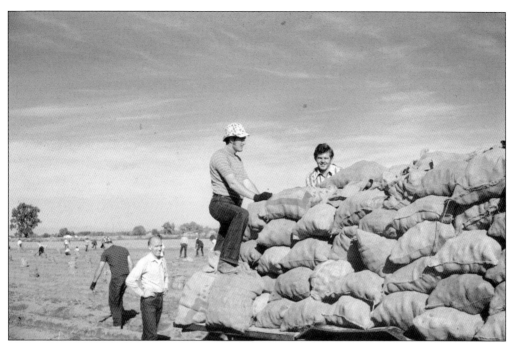

The photograph above shows members of the LDS Fifth Ward "bucking" (tossing) full potato sacks and stacking them on a truck on the church farm north of Rigby in 1973. The picture below shows the mechanization of the harvesting process. The potato harvester digs, transports, and dumps the potatoes in a truck for transportation. (Above, courtesy George Marriott; below, Idahoan Foods, LLC.)

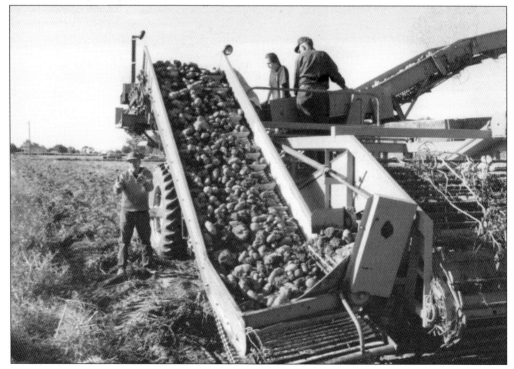

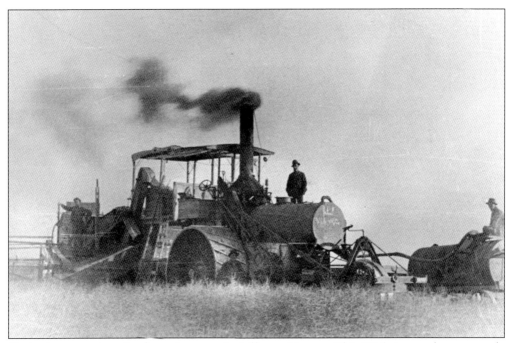

Grains have continued to be major crops in Jefferson County. This 1915 picture shows an early threshing machine. (Courtesy JCHS.)

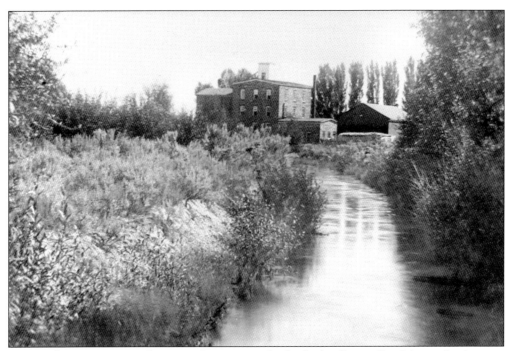

A. S. Anderson, a surveyor, farmer, and community leader, built a flour mill in Menan that became operational on September 16, 1894, and a gristmill in 1896. In 1901, the mill burned down and was rebuilt as a large three-storied black sandstone structure operated by waterwheel. This picture shows the mill run canal. It operated until the 1920s. (Courtesy JCHS.)

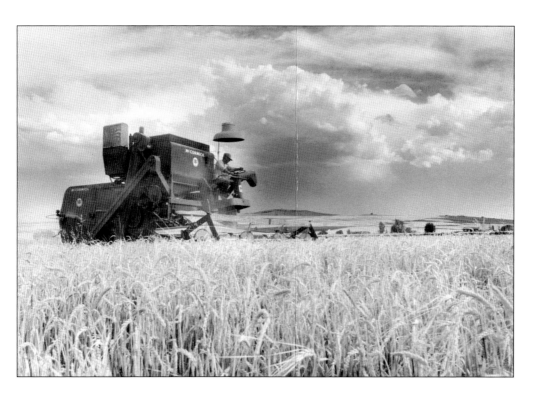

Since the construction of breweries in Bonneville County, barley has become an important crop in Jefferson County. Both pictures show the harvesting of barley in the Ririe area. The picture above was taken in 1985, while the one below was snapped in 1973. (Both courtesy *Post-Register*.)

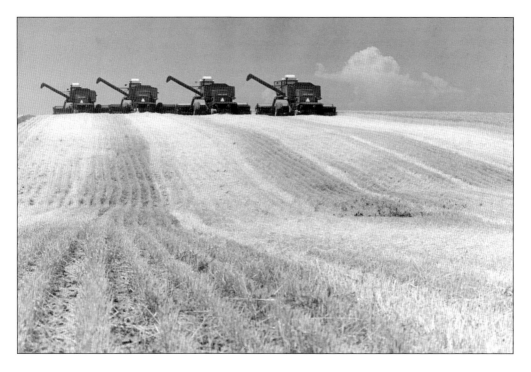

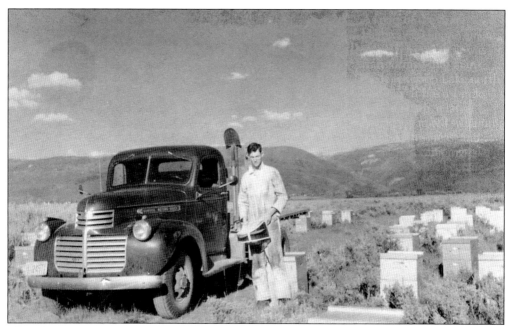
This photograph shows Bartley Stowell hauling beehives for the Meyers Honey Company in the Mud Lake area to Afton, Wyoming, in 1946. (Courtesy Bartley Stowell.)

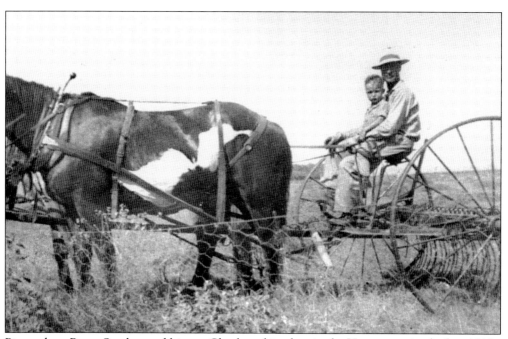
Pictured are Reese Sanders and his son Charles raking hay in the Hamer area in the late 1940s. (Courtesy Dave Sanders.)

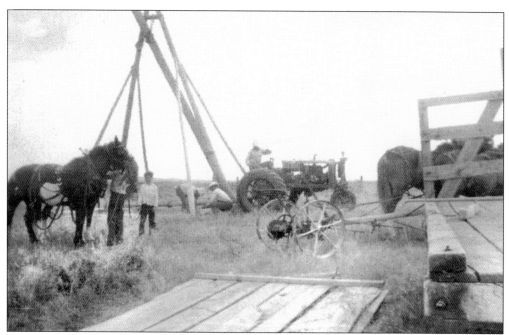

As seen in this 1940s image, the derrick boy loaded hay gathered in the field and dropped it on the wagon for transportation. (Courtesy Dave Sanders.)

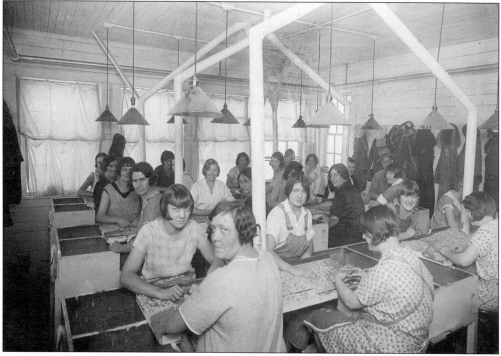

For decades Jefferson County was a leader in the production of seed peas. More than 3,500 and 4,500 acres were planted annually. In 1930, the Canner's Seed Corporation opened its factory in Lewisville. For more than 50 years it handled 1.2 million pounds of peas annually. This 1940s photograph shows workers checking seed peas. (Courtesy JCHS.)

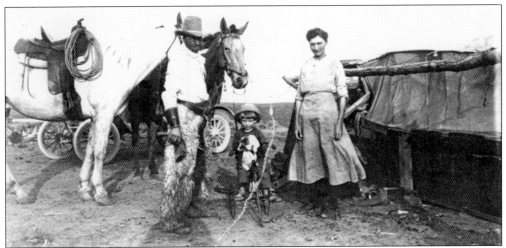

In 1919, Vern Crystal and brother-in-law Ace Randall started taking cattle herds from Garfield, Grant, Rigby, Lorenzo, and Coltman. From April 20 to May 15, they collected all the cattle into a common herd and held them in a corral until all cattle were gathered. There were about 500 head of cattle to drive from Grant and Garfield to Roberts. They turned the herd out on the open range from Roberts east along the Butte and Market Lake Canal and the Big Buttes to the North Fork Bridge west of Rexburg, then north to Plano and the Elgin Bench, and then west of Hamer, an area of about 15 square miles. Around September 15, they gathered the cattle from the big range and returned them back to their owners. They charged $3 per head for the summer season. In 1941, Vern Crystal purchased rangeland on the Buffalo River in Island Park. This enabled him to increase his herd. The picture above shows Vern and Bessie Crystal and daughter Nola at a cow camp. They took care of herd cattle and milked cows. They separated the milk and took the cream to Roberts and Hamer. The picture below shows the Crystal roundup in the 1960s and Kenneth Jones carrying a big stick. (Both courtesy Lois Jones.)

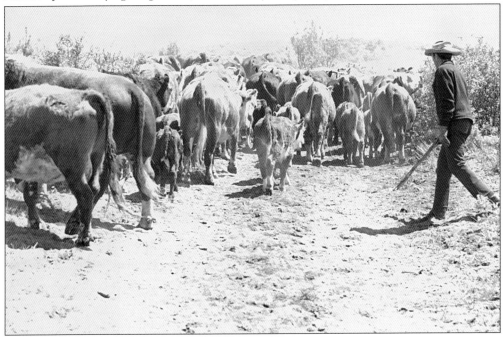

In 1926, the Charles A. and Sarah Sanders family left Rexburg to farm and raise cattle on Camas Creek about 8 miles west of Hamer. Little land was being farmed then in the area. Life was a struggle; people worked hard and had to be frugal to survive. The photograph shows the Sanders cabin, corral, and barn. (Courtesy Dave Sanders.)

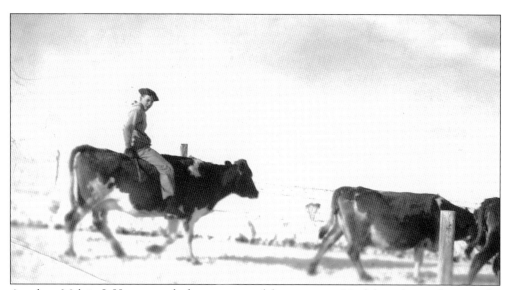

As a boy, Melvin J. Hansen took the cows to and from pasture. He did not have a horse, so he rode one of the cows. (Courtesy Melvin J. Hansen.)

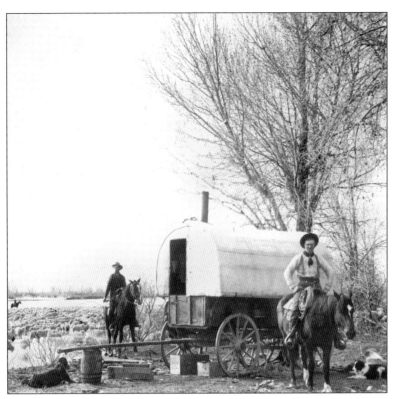

In 1896, Hyrum Severson formed a livestock company with G. P. Johnson that operated for more than 26 years. Their sheep bands grew to 30,000 head (1,000 bands) to become the largest wool producer in Idaho. This picture shows Hyrum Severson and his brother Levi herding their sheep between Driggs and Taylor's Mountain around 1899. (Courtesy Doug Crossley.)

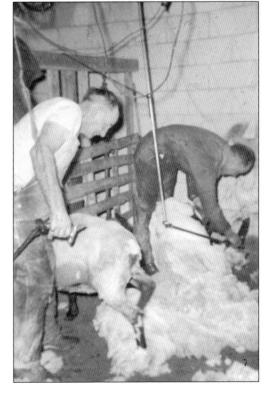

Ray Hall of Rigby started shearing sheep when he was 15 and continued for 60 years. He left home in the spring for three months traveling all over the West. He could shear 100 sheep in a 10-hour day. He was in great demand among small herds because he was a clean shearer. The photograph shows Ray Hall and son Darius shearing sheep in the 1960s. (Courtesy Myrtle Reddick.)

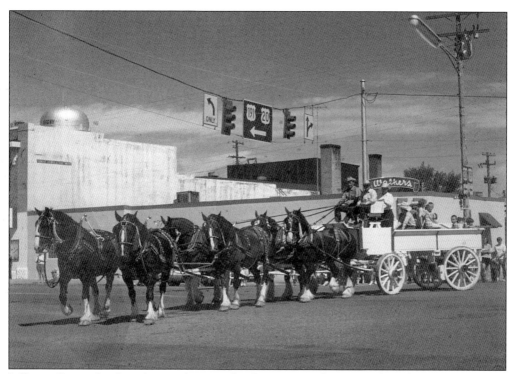

Jefferson County has been known for many fine horsemen and women. The following are Jefferson County inductees to the Eastern Idaho Horsemen Hall of Fame: Wells Barney of Lewisville (1997), Floyd Crystal of Garfield and Ted Furniss of Grant (1998), Vearl Crystal of Grant and Dean T. Kunz of Ririe (1999), Leland Barney of Lewisville (2000), J. Neal Erickson of Lewisville and Gwen Hilker of Garfield (2001), Mitch Jacobs of Hamer and Nik and Jackie Hillman of Hamer (2003), and Dewey Smuin of Monteview (2008). The photograph shows Wells Barney's Belgian team participating in the Jefferson County Stampede Parade around 1972. (Courtesy JCHS.)

Vern Crystal herds cattle in Island Park in the 1970s. (Courtesy Lois Jones.)

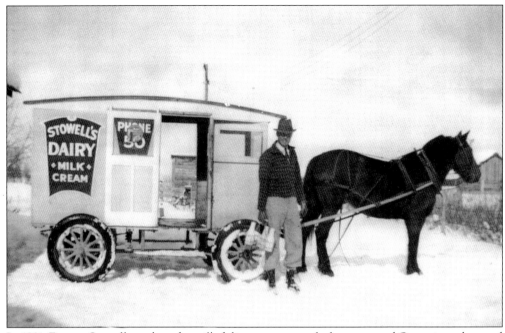

In 1931, Eugene Stowell purchased a milk delivery wagon and a horse named Queenie and started a one-horse dairy. Each day Stowell and his wife, Ada, bottled 12 to 14 cases of raw milk by hand and delivered them house to house for 8¢ a quart or 12 quarts for a $1. Queenie knew every stop on the route and only missed three days in 13 years. (Courtesy Bartley Stowell.)

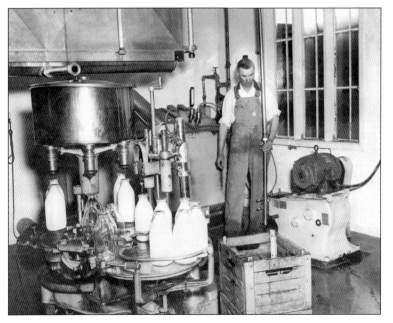

In 1935, Eugene Stowell purchased George Chapman's dairy and moved to Rigby. Quickly the dairy became a family operation. In 1941, Stowell's Dairy installed a new automatic bottle filler. (Courtesy Bartley Stowell.)

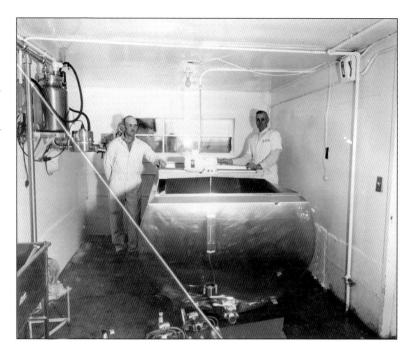

This 1955 photograph shows Leland Call and Eugene Stowell in Call's milking barn and the first bulk milk tank in the Upper Snake River Valley. (Courtesy Bartley Stowell.)

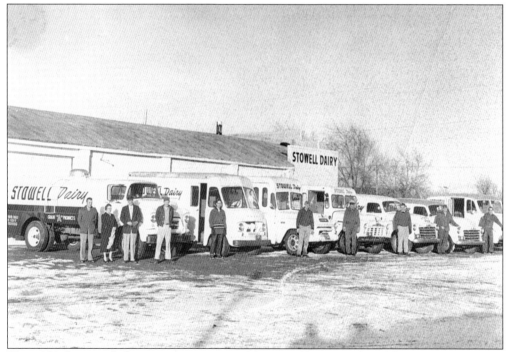

This 1956 photograph shows an exterior view of the Stowell Dairy with its delivery and milk trucks on South State Street in Rigby. In 1960, Eugene Stowell retired and sold the dairy. Pictured from left to right are Kay, Ada, and Eugene Stowell, Merlin Merrill, Emil Chavez, Gene Packer, Paul Stevens, Bartley and Vee Stowell, and Robert Olson. (Courtesy Bartley Stowell.)

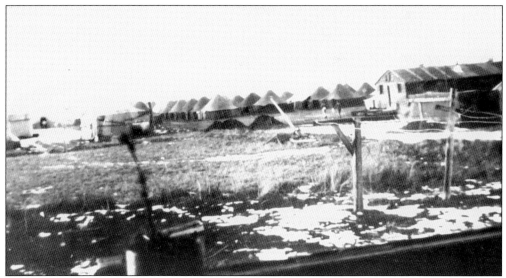

During World War II, a prisoner-of-war camp was established on the farm of Mark Price. The German prisoners worked local farms to ease the severe worker shortages. This photograph was taken from Price's kitchen window in 1945. (Courtesy JCHS.)

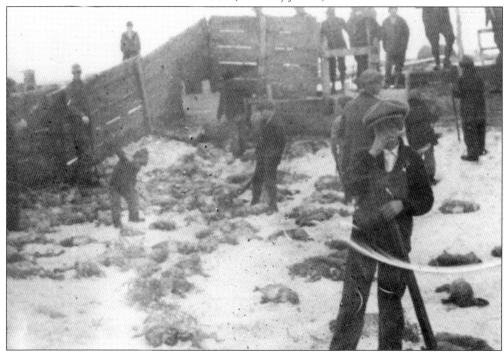

Jackrabbits are destroyers of planted crops. In desert areas they usually confine themselves to sagebrush, but their populations exploded every 7 to 10 years in eastern Idaho. Rabbit drives were organized to control the populations. The earliest advertised rabbit drive was held on January 13, 1906, as part of a "whole day of sporting enjoyment" (with wrestling and boxing), as reported by the *Rigby Star*. At least one drive was held every decade. Since large crowds participated in the drives and guns caused safety issues, other methods were developed. The rabbits were corralled into enclosures and then clubbed with bats or sticks. This picture shows a 1920s drive. (Courtesy JCHS.)

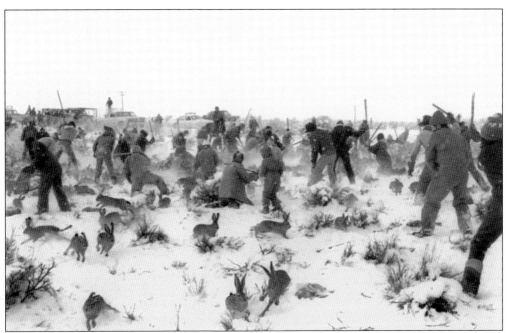

While the first drive was held in Rigby, later drives were held in Roberts and then in the Mud Lake and Hamer areas. A bounty would be paid per rabbit, and the pelts were sold to furriers and shipped. Jackrabbits are shown here being chased and clubbed. (Courtesy Dave Sanders.)

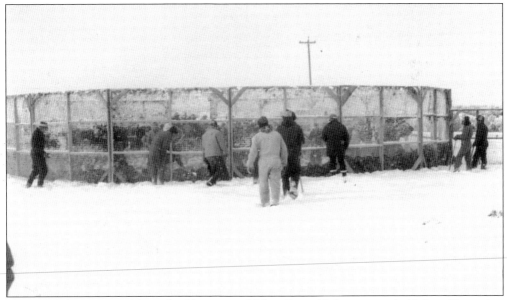

Since crop losses caused by jackrabbits topped $5 million, 10 drives were held from November 1980 through January 1981, killing 120,000 rabbits. The international outcry caused thousands of hate letters to be sent to Mud Lake farmers. Local residents responded defiantly, wore "bunny basher" pins, and continued the drives. An animal rights organization obtained a temporary injunction to stop the drives. The local district judge refused to grant a permanent ban and lifted the temporary injunction. Since new biological methods have been used to reduce rabbit reproduction, no further drives have been necessary. (Courtesy Dave Sanders.)

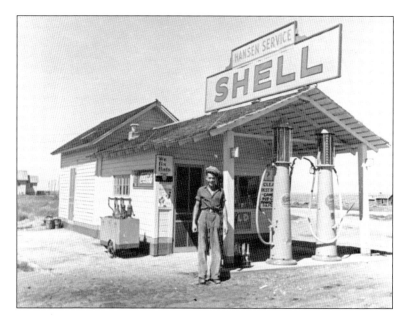

George Heber Hansen was a farmer, a dairyman, an express agent for the Oregon Short Line, and owner of this gas station in Hamer. The Hansen family operated the station (1935–1940). Pictured is Hansen's son Clifford around 1938. (Courtesy Melvin J. Hansen.)

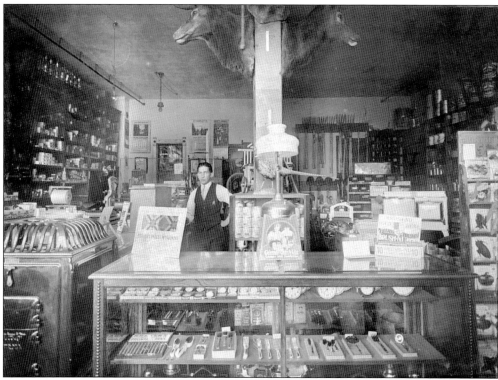

A. P. "Abe" Smith became interested in the hardware business and built the Smith Block on the north side of Main Street in Rigby. The building was completed in 1909 and rented to the Sims Coal and Commission Company. They employed Abe Smith as a salesman, traveling the countryside buying potatoes and selling farm equipment and hardware. In 1912, Smith purchased the Sims Company stock and established the Smith Hardware Store. It operated on Main Street in Rigby until it was sold in 1965. Abe Smith is shown in the store in the 1920s. (Courtesy JCHS.)

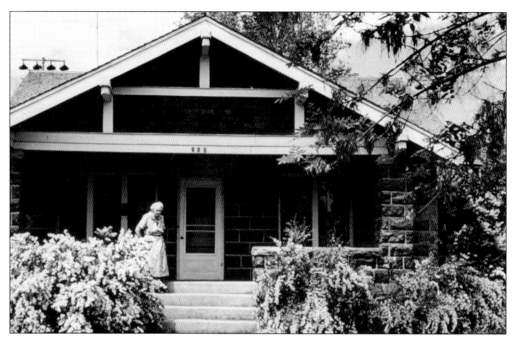

There were two maternity hospitals in Rigby. These birthing centers allowed women to deliver their babies assisted by local doctors and nurses and to stay 5 to 10 days before returning to their homes. This picture shows Alice Jane Fisher Goody (1882–1957). After her husband's death, Goody converted her home into a maternity hospital and operated it for 17 years (1932–1949). Eight hundred babies were born there. (Courtesy Gwen Ellsworth.)

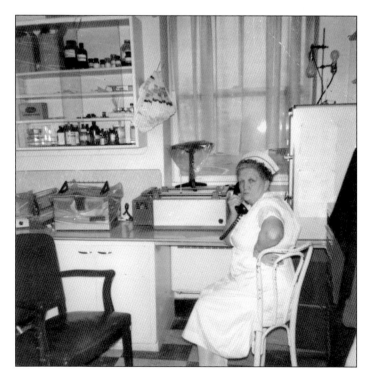

This picture shows Beatrice Walker (1902–1995). After raising her seven children, she attended the LDS Hospital Nursing School in Idaho Falls and became a licensed practical nurse in 1949. She assisted her daughter Zelta Hendricks in operating the Hendricks Maternity Hospital (1948–1962) in Rigby on North State Street located next to the home of Dr. Aldon Tall. (Courtesy Enid Storer.)

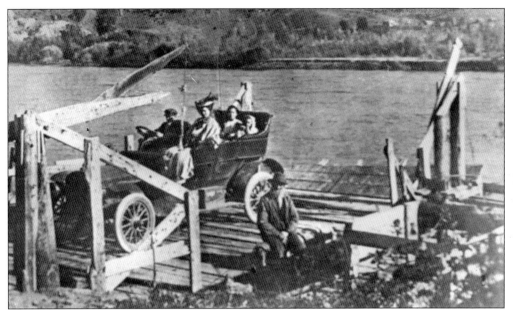

Jefferson County's more than 36 miles of the Snake River, its tributaries, and countless canals required means for their crossing. Before the construction of bridges, ferries were established at important crossings. The Heise ferries were the last ones operated in Jefferson County. In 1899, Elof Nelson, with the encouragement of Richard Heise, built a ferry about 3 miles above Heise. The ferry consisted of two boats with timbers over the top joining both boats. In 1906, ninety-nine-year-old Thomas Morgan purchased and successfully operated it for five years. The ferry was operated by the Morgans until Ezra Rapp purchased the upper ferry from Earl Morgan in about 1942. Ezra Rapp operated the ferry with his sons Richard, Mark, and Bob until 1946. The above photograph shows Thomas Morgan sitting on the side of the ferry. Below is a 1940s photograph showing members of the Rapp family; Ezra Rapp is on the far left. (Above, courtesy JCHS; below, Joyce Marriott and JCHS.)

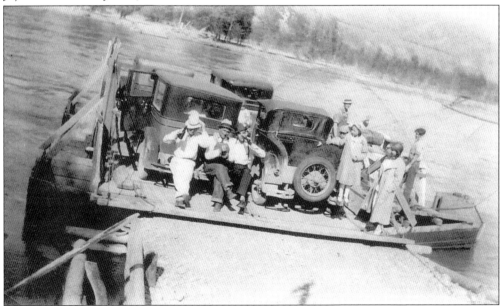

Ferry traffic was so heavy that it required another ferry be added in 1907. Elof Nelson built the lower ferry about 1 mile below Heise. This was a faster route. In 1919, Eugene Holt of Salt Lake City purchased the lower ferry from Nelson and it was said he ran it for 20 years without an accident. High waters in the spring and ice during the winters made it difficult to run the ferries. In 1946, the old Lorenzo Bridge was moved to the site of the lower ferry, opened to traffic, and ended ferry traffic in Jefferson County. The photograph at right shows the lower Heise ferry looking south around 1919. The 1975 picture below shows the Bertha Gavin Bridge at Heise. (Both courtesy JCHS.)

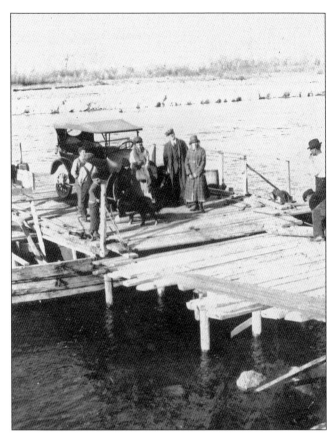

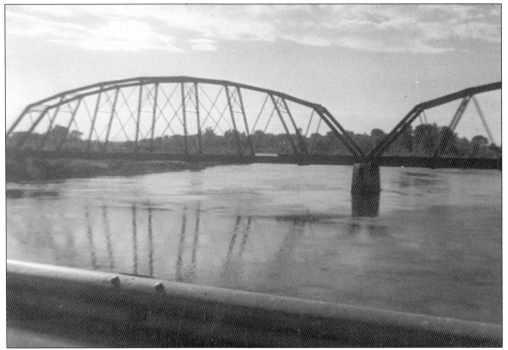

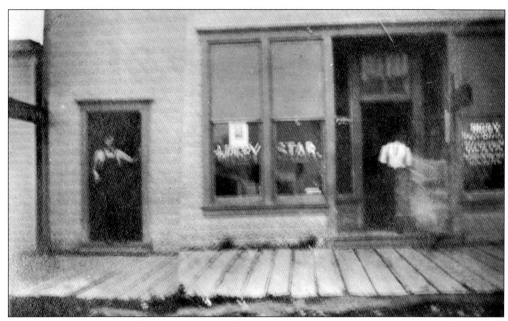

The *Jefferson Star* is the oldest business in Jefferson County. On March 5, 1903, the *Rigby Star* was founded by J. W. Harry. Its first three years were chaotic, with more than six editors and various managers. In 1905, J. W. Jones became editor. The Jones family operated the weekly newspaper from 1905 to 1975. In 1975, new owner Ken Carr changed its name to the *Jefferson Star* to signal that it was the voice for the entire county. It was purchased by the Idaho Falls *Post-Register* in 2007. The picture above shows the *Rigby Star*'s first office on the southeast corner of Clark and Main Streets. For 70 years, the *Rigby Star* was a family operation. The 1916 photograph below shows the 70 years of editorship of the *Rigby Star*. Pictured from left to right are J. W. Jones (editor, 1905–1918), Hope Bennett (later Mrs. Bill Jones, editor, 1955–1975), Bill Jones (editor, 1919–1950), and Irwin Jones (1918–1955). (Both courtesy JCHS.)

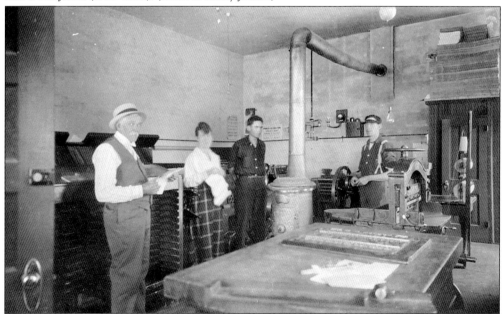

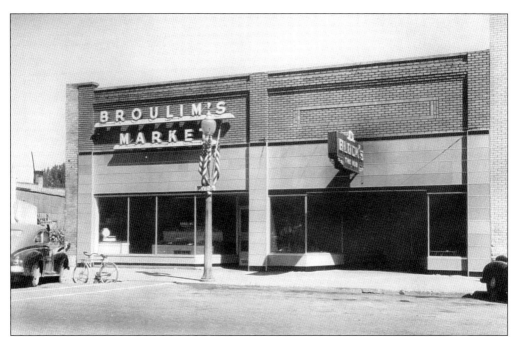

In 1922, Charles Broulim (1884–1974) arrived in Rigby, purchased the A. L. Paul grocery store, and established Broulims. For more than 12 years, Broulim's Market operated successfully. Suddenly it was destroyed by fire on February 1, 1951. Charles Broulim and employee Norman Hall entered the burning building and retrieved the store's records. While the building was a total loss, Broulims opened temporarily in the Memorial Building. They rebuilt in their old location and remained there until 1975. They opened a new store on State Street and Fremont Avenue just a block north of their old store, and 20 years later, they moved into a newer and larger building on State Street. Today Broulims owns seven grocery stores in eastern Idaho. Above is a picture of the original store on East Main Street in Rigby. Broulims is a family business; at right are father and son Charles and C. Richard Broulim in 1961. (Both courtesy C. Richard Broulim.)

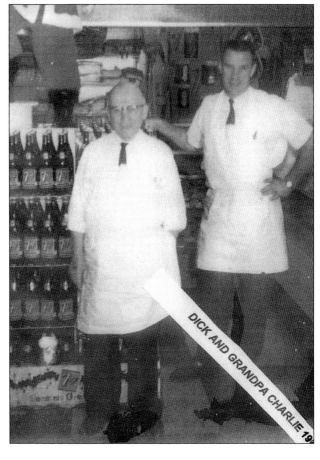

Adam Berdett Eckersell (1904–1984) began his work in mortuary service in Rexburg in 1925. His uncle Henry Flamm helped him organize a funeral parlor and furniture store in Rigby. The business was purchased from Ira Taylor in 1928 and was located in part of what was known as the J.C. Penney Building. The furniture was located upstairs and was moved there by a hand-operated elevator. The photograph above shows an interior view of the original office. Caskets were located downstairs, furniture upstairs, and a prep room was behind the drapery. In 1946, Eckersells moved to its present location on west Main Street and discontinued furniture three years later. It has employed four generations of the Eckersell family. At left are A. B. and Pearl Eckersell (1909–1999), who were also well-respected church and civic leaders. A. B. served as an Idaho State Senator (1937–1940), Rigby mayor (1959–1966), and was very active in state and national funeral director associations (serving as president for both organizations). Pearl was very active in the LDS Church Relief Society and numerous civic organizations. (Both courtesy Bruce A. Eckersell.

Idahoan Foods, LLC, was founded as the Idaho Fresh-Pakin in October 1960 by a group of Idaho potato growers and local businessmen. Lewisville was chosen for the modern 400,000-square-foot plant and storage facilities in the "heart of potato farmland." While only 50 people were on the company's first payroll, 5 million pounds of dehydrated potatoes were produced. Each year, the company buys more than 420 million pounds of fresh potatoes and has the capacity of producing 50 million pounds of dehydrated potatoes. The products are distributed internationally. The aerial photograph below, looking south, shows the Idahoan Foods plant in Lewisville, just south of the Dry Bed Channel. At right is Gale Clements (1918–2002), one of the company's original founders and chief executive officer for 41 years. (Both courtesy Idahoan Foods, LLC.)

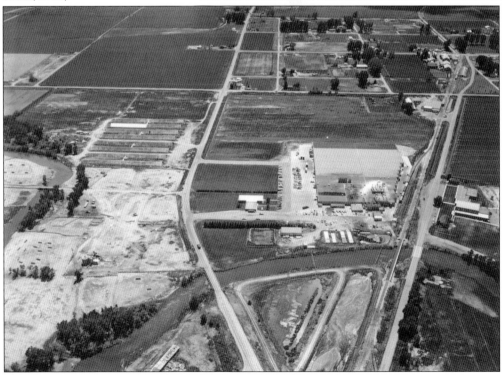

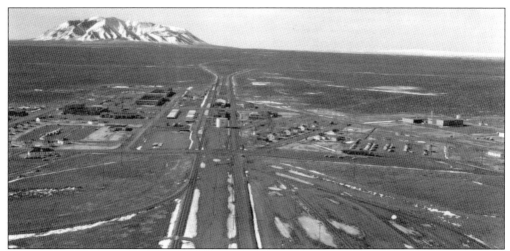

In 1979, the Atomic Energy Commission announced that the United States would establish the Idaho National Laboratory (INL), a nuclear testing station in eastern Idaho on the former navy gun testing site, using 400,000 acres of the Snake River lava plains west of Idaho Falls and southeast of the city of Arco. While no facilities are located in Jefferson County, 12,000 acres are part of INL's security zone. There are more than 600 Jefferson County residents employed at the INL. Their yellow, white, and silver buses are seen twice daily as they depart and return. (Courtesy Bonneville County Historical Society—Museum of Idaho.)

The first orientation meeting for interested law enforcement and civil defense officials at the INL was held on April 5, 1962, 15 months after a portable reactor, SL-1, was destroyed and its three operators killed (January 3, 1961). Jefferson County's civil defense director Clifford Smith is at the far right. (Courtesy JCHS.)

Seven

CIVIC AND SOCIAL LIFE

While the people of Jefferson County are hard working, they also enjoy a wide range of activities. They are committed to their churches, communities, and schools and participate in numerous social activities, including dances and sports. Many enjoy hunting and fishing. Others are talented musicians and perform individually or in groups. They also are involved in community-sponsored carnivals, civic projects, concerts, fairs, parades, and rodeos.

They have joined together to form organizations to advance civic causes and promote specific interests, personal development, or enjoyment. Some of the organizations are affiliated with national groups, while others are unique to Jefferson County. National organizations include the Lions Club (founded in 1928), Business and Professional Women (1929), the Daughters of Utah Pioneers (1934), and the Rotary Club (1954). Local organizations include the Study Club (1912) and the Jefferson County Sheriff's Posse (1945).

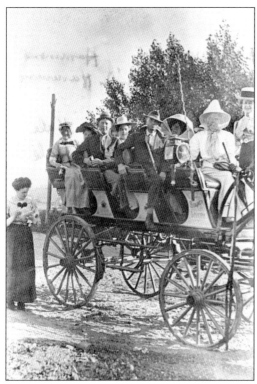

In the summer of 1912, Maud Nye invited a group of women and organized the Study Club for social enjoyment and intellectual improvement. They studied a varied program that included literature, art, eugenics, history, homemaking, childcare, and travel. This 1912 photograph shows the charter members of the Rigby Study Club. (Courtesy USRVHS.)

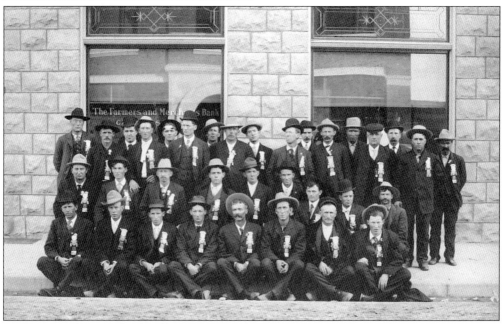

Modern Woodmen is the third-largest fraternal organization in the United States. In 1910, they boasted one million members. Between 1900 and 1970, various camps existed in Jefferson County. Members were first attracted to the availability of insurance and annuities and later to its service and social activities. This photograph shows the Menan Camp attending a convention in Idaho Falls on December 9 and 10, 1907. (Courtesy JCHS.)

The Future Farmers of America organized chapters at all Jefferson County high schools. Rigby High School's chapter was organized in 1935. The photograph above was taken in 1949. The photograph below shows the Roberts High School's chapter before leaving for the 1957 Fat Stock Show in Idaho Falls. (Above, courtesy Douglas Crossley; below, JCHS.)

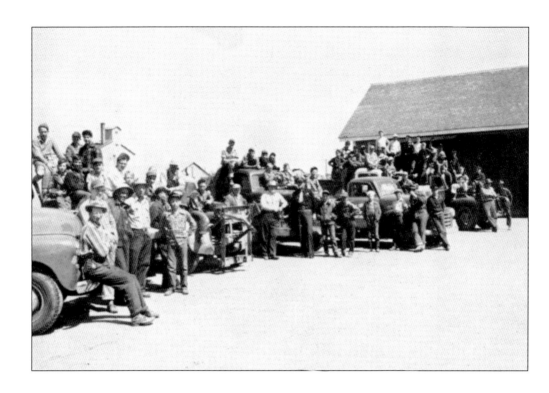

In January 1916, the first Boy Scout troop was organized in Jefferson County by local businessman W. E. Eliason. By 1924, seven troops had been organized. A 1950 service project to pick up trash along Highway 191 is shown above; it picked up 10 trucks of trash. The photograph below shows the Rigby LDS Second Ward Boy Scouts on the way to the Annis Buttes for a sledding and skiing excursion in January 1939. (Above, courtesy JCHS; below, Bartley Stowell.)

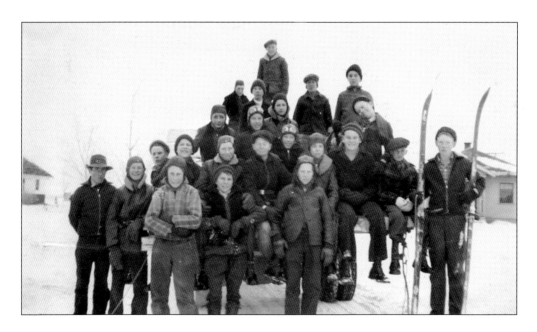

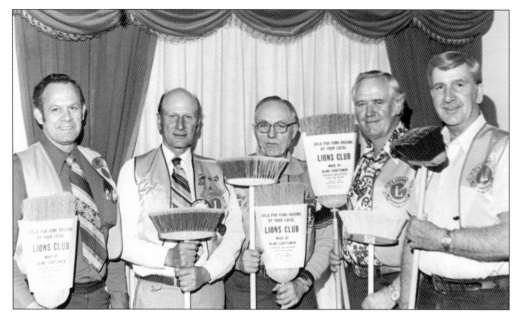

Lion Clubs were organized in Hamer, Rigby, Ririe, and West Jefferson. F. C. Kanzier of Salt Lake City, Utah, started the Rigby club on March 2, 1928. The Ririe club was organized on May 12, 1947, the West Jefferson Club in 1956, and the Hamer's club in 1974. This photograph, taken about 1980, shows Rigby Lion's Club members, from left to right, George Marriott, Lloyd Gneiting, Clarence Wilde, Lowell Horman, and Grant Smith with brooms they were selling. (Courtesy JCHS.)

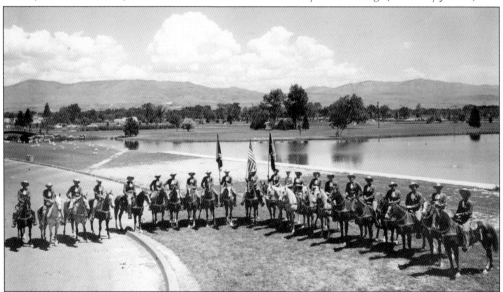

On August 5, 1945, a group of Jefferson County horsemen organized the Jefferson County Mounted Posse. They made their first public appearance at the Jefferson County Roundup that was held from August 15 to 17, 1947. They have demonstrated well-executed drills at numerous rodeos throughout eastern Idaho and Montana and have won numerous awards. Members are responsible for paying their own expenses and maintaining their own horses. They are available to respond to calls from the county sheriff for searches. The photograph shows the posse on July 2, 1950. (Courtesy Bartley Stowell.)

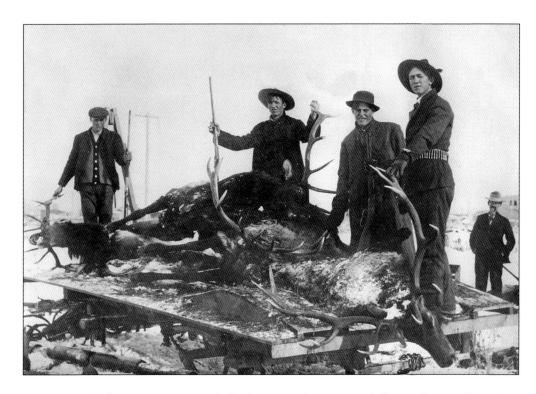

Hunting and fishing are important for both men and women in Jefferson County. They first provided significant food sources and later they became important recreational activities with family and friends. The picture above shows the Olsen brothers' successful elk hunting trip in the 1930s. Below, Bert Robinson leads a fishing party in the Mud Lake area in the 1920s. (Above, courtesy JCHS; below, MLHS.)

Rodeos are important activities in Jefferson County. The first rodeos were held in Camas. This 1918 photograph shows attendees watching the events. The Grant rodeo was held around July 24 from 1920 to 1927 at the original baseball diamond. Cars and wagons served as fences for the arena. The photograph below shows the first rodeo on July 24, 1920. Slim Arrington saddles a bronco while Vern Crystal snubs it. Rube Boam is at left in the foreground, and Jude Payne is at right. (Both courtesy Guen Taylor.)

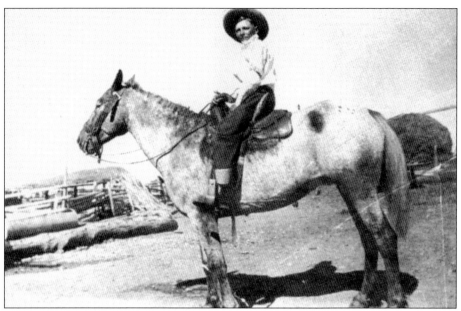

The Jefferson County Rodeo moved to Lewisville in 1928 and was held there until 1937. Originally it was organized to raise funds to build a new LDS church house. It was held on July 24 or the weekend closest to the date. After the 1936 rodeo, the committee turned over $3,500 to the Lewisville LDS Church for its building fund. The church was completed, paid for, and dedicated in 1938. The last Lewisville rodeo was held on July 9 and 10, 1937. The photograph above shows Vearl Crystal riding his horse, Old Chief, shortly before the rodeo on July 24, 1931. The Jefferson County Stampede moved to Rigby in 1939 and continues to be held there annually on the second weekend of June. The photograph below shows bareback riding in the 1970s. (Both courtesy JCHS.)

In 1920, a professional baseball league opened in southeastern Idaho. The Yellowstone League included teams in Blackfoot, Idaho Falls, Rexburg, Rigby, Pocatello, and St. Anthony. Each team consisted entirely of professional ballplayers except for the Rigby Bears, who employed one local boy, George Cunningham. The final game was played between Rexburg and Rigby on August 19, 1920. Rexburg won 5-3. The league existed for only one season—southeastern Idaho could not afford professional baseball. The picture shows the 1920 Rigby team. George Cunningham is the fourth player from the left. In front, Jack and Fisher Ellsworth served as mascots. (Courtesy JCHS.)

Most communities had baseball teams in amateur leagues. This 1930s Grant team included John Lee, Grant Pratt, Lyman Taylor, Ace Randall, Francis Gardner, William Webster, and Dell Taylor. (Courtesy Guen Taylor.)

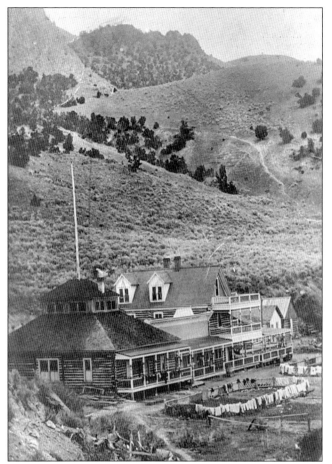

German-born Richard Clamor Heise arrived in Idaho in the 1890s. He suffered from severe rheumatism and was told of hot springs on the north bank of the Snake River. He filed his claims and started developing a resort patterned on European spas. He constructed a shelter for the hot springs and a hand-hewn log lodge for guests. Heise Hot Springs became widely known as a health resort and recreational facility. The Heise family sold the resort in 1942 to Robert and Elsie Quinn. The Quinns built a new large swimming pool, picnic area, and hot pool buildings. In 1974, a nine-hole golf course, pizza parlor, and pro shop were added and dressing rooms and observation stands rebuilt. At left is a 1910 view showing the lodge and hot springs. Below is Heise Hot Springs in 1920. (Both courtesy JCHS.)

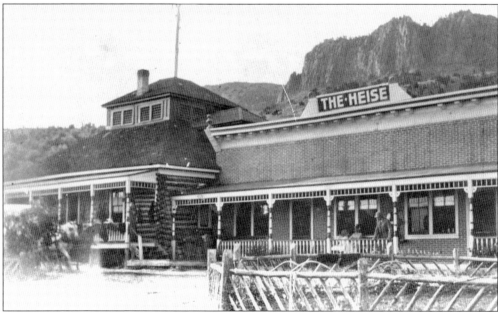

The 1905 Market Lake Band consisted of German and Czech members. The roster included Ed Ledvine, Ned Neyman, Ed Pospesil, Jacob Hockwart, Fred Vystercil, Lou Ledvine, and Frank Eickinger. It was called on frequently for services throughout the Upper Valley winter and summer. By 1910, the band had become known as the Roberts Concert Band. (Courtesy USRVHS.)

The Menan Band was organized in the late 1880s. It gave open-air concerts, played on holidays, and had a four-horse wagon for transportation. It led John R. Poole's funeral procession from Menan to the Annis Butte cemetery in September 1894. It disbanded at the beginning of Word War I. (Courtesy BYUI-RB.)

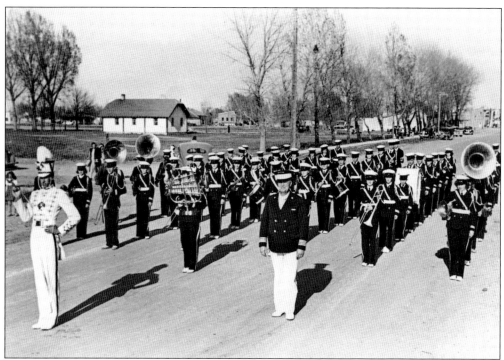

All county high schools had active music programs. The picture above shows the Rigby High School marching band in 1945. Director William W. Brady (1886–1964) arrived in Rigby on July 15, 1939. He organized a band, orchestra, and choruses in senior and junior high schools and started music classes in the elementary school. His bands and orchestras won countless first-place district, state, and national awards. The photograph below shows the 1941 Ririe High School band. (Both courtesy BYUI-RB.)

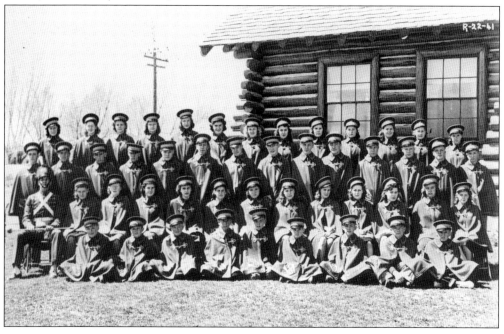

In 1956, the choral group The Chansonettes was organized by Mary Lou Wright and Renee Graham to serve church and community. They presented programs in various locations as far north as Island Park and as far south as Salt Lake City. This well-respected, 25- to 30-member group disbanded in 1995. The photograph shows the 1958 Chansonettes that featured Mary Lou Wright as conductor and Nola Jensen as pianist. (Courtesy BYUI-RB.)

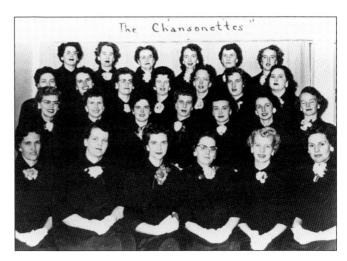

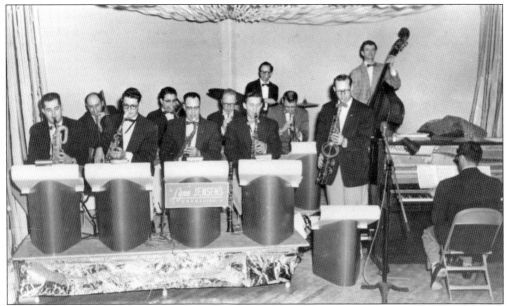

During the 1930s, 1940s, and early 1950s, numerous dance halls operated throughout the Upper Snake River Valley. A variety of bands and orchestras performed in these halls. One of the later groups was the Lynn Jensen Band, which operated throughout the valley from 1950 through 1970. As a young man, Jensen purchased a used tenor saxophone for $35, and by the age of 13, he was performing in an adult dance band. After attending Ricks College, he married and moved to Rigby. There he organized his own dance band with seven musicians. He used as many as 15 musicians for formal dances at Ricks College, Idaho State University, and some high school performances. (Courtesy BYUI-RB.)

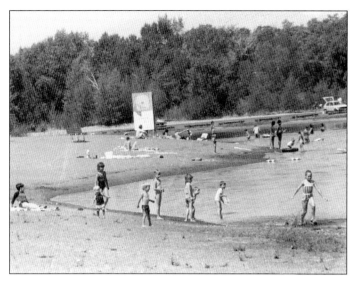

As part of the State Highway 20 improvements in 1975, a gravel pit was transformed into man-made Jefferson Lake north of Rigby. It has a 1-mile walking path, a large beach, separated swimming and boating areas, and picnic and camping facilities. It has become a very popular gathering place during the summer for residents and visitors. This 1978 photograph shows children playing on the sandy beach and the lake. (Courtesy JCHS.)

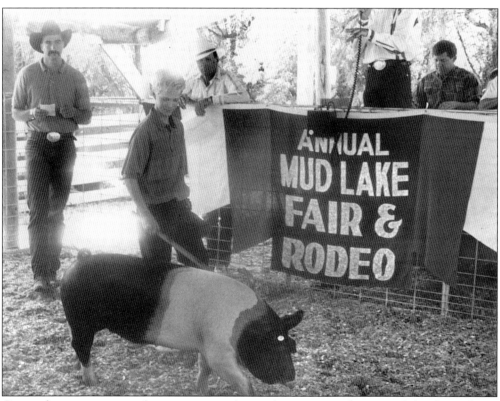

County fairs were an annual opportunity in August for county residents to exhibit their talents. In 1933, Ririe's Future Farmers of American organized a Harvest Festival to celebrate the fruits of the harvest. In 1944, the Harvest Festival became the Jefferson County Fair, and it operated in Ririe for 31 years. In 1975, the Jefferson County Fair moved to new facilities in Rigby. The Mudlake Fair and Rodeo began on August 30, 1950, at Terreton Elementary School and was sponsored by the Terreton Farm Bureau. This photograph shows pigs being judged at the Mud Lake Fair in the 1960s. (Courtesy JCHS.)

In 1994, the Jefferson County Historical Society established the Jefferson County Hall of Fame to recognize current and former residents that made state, national, and international contributions. The first inductee was Philo T. Farnsworth (1906–1971), the inventor of the television. In 1918, his family left Utah and moved to a farm east of Rigby, and Philo attended Rigby High School. The idea for the television came as he plowed his father's fields. He drew a diagram on a school's blackboard and explained his ideas to his chemistry teacher, Justin Tolman. Tolman recalled this conversation as he testified during Farnsworth's patent hearing in 1934. At right, Farnsworth holds a television tube around 1933. Below, Farnsworth presents the original tubes built in 1928 to Rigby High School in June 1956. (Both courtesy JCHS.)

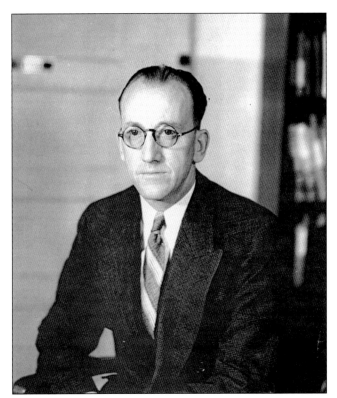

Other inductees to the Jefferson County Hall of Fame include noted author Vardis Fisher and biomedical engineer Wayne Quinton. Pictured here is Fisher (1895–1968), who was born in Annis and graduated from Rigby High School, the University of Utah, and the University of Chicago. He taught English at various institutions such as the University of Utah, which included student Wallace Stegner. His novels include *Toilers of the Hills* (1928), *Children of God* (1939), *Tale of Valor* (1958), and *Mountain Man* (1965), which became Robert Redford's memorable film *Jeremiah Johnson*. (Courtesy JCHS.)

Wayne Quinton (1921–) was raised in the Rigby area. He has been called the "father of biomedical engineering." He invented the treadmill, the critical shunt used in kidney dialysis, a new method of oxygenating blood during surgeries, and numerous other devices and methodologies. (Courtesy JCHS.)

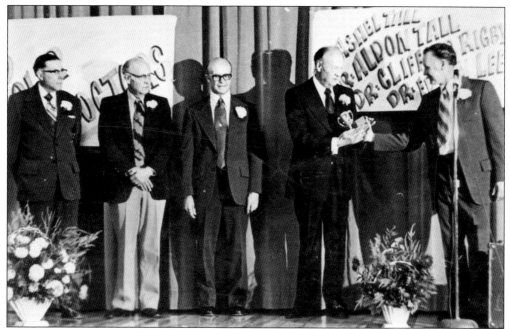

Numerous doctors have served Jefferson County. The photograph recognizes Doctor's Appreciation Day, held on October 3, 1973, to honor the county's four doctors: Clifford B. Rigby, Edwin Lee, and Asael and Aldon Tall. A reception was held in the Rigby LDS Stake Center. People stood in long lines to thank them for their 30 years of service. They were recognized not only for their medical service but also their service to the schools, churches, and civic projects. (Courtesy JCHS.)

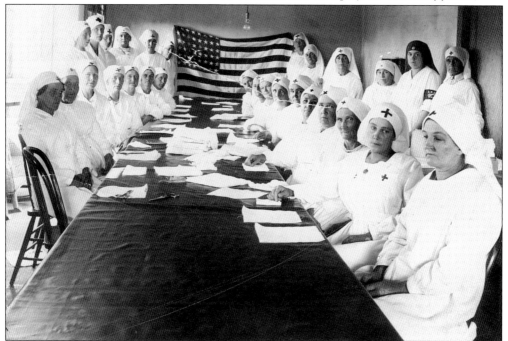

The local Red Cross was organized in Jefferson County in 1915. This photograph shows bandages being wrapped in 1916. (Courtesy JCHS.)

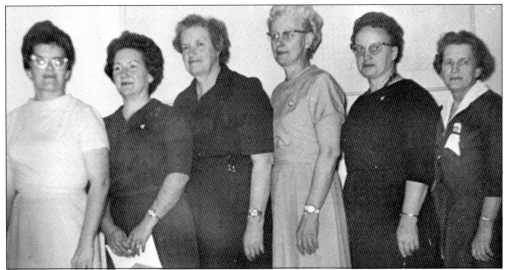

After the passage of the Social Security Act of 1937, Jefferson County was recognized as part of Idaho's State Public Health Program. The new office consisted of two nurses and a secretary. This undated photograph shows public health nurses, from left to right, Norma Johnson, Elaine Johnson, Mary Gunderson, Elaine Hogan, Bonnie Carson, and Lenore Standiferd. Gunderson and Standiferd served together for 22 years (1947–1969). Gunderson started in 1944 and retired in 1971 after 27 years. (Courtesy JCHS.)

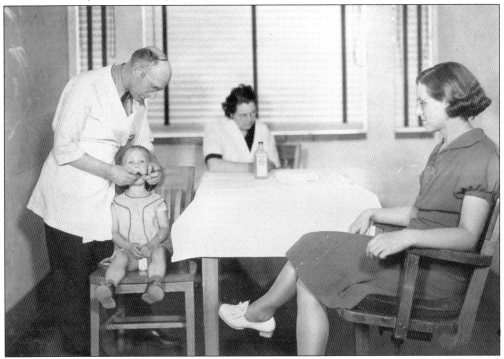

In the late 1940s, preschool physicals were established for all incoming students. They were weighed, measured, had their urine tested, and sometimes dental checks were made. Immunizations were given and vision screened. This 1950s photograph shows Dr. Floyd Johnson and his wife, Clara, providing dental checks. (Courtesy JCHS.)

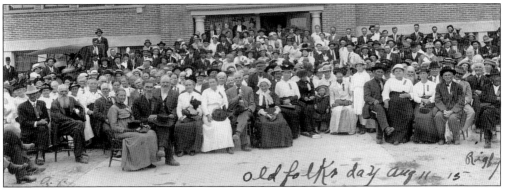

For more than two decades, an "Old Folks Day" was held annually to honor the area's pioneers. Attendees of the celebration pose here for a shot on August 11, 1915, at Rigby's new high school. (Courtesy JCHS.)

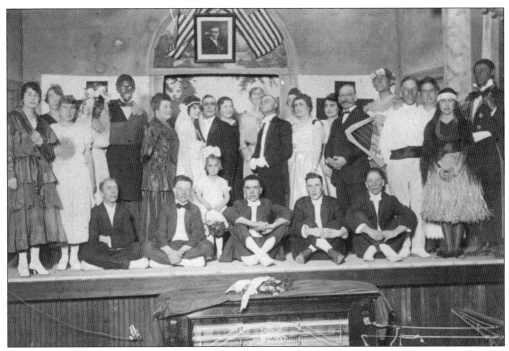

For more than a century, dramatic and musical theater has been presented throughout Jefferson County via its churches, clubs, and schools. This 1916 photograph shows the cast of a Red Cross musical show presented in Rigby. It was organized by Mary Hewitt of Ririe while her husband was serving as the LDS mission president in Denver, Colorado. (Courtesy BYUI-RB.)

The Jefferson County Historical Society was founded on June 26, 1975, to collect, preserve, and promote the history of Jefferson County, Idaho. For 13 years, its collections were stored in boxes and shifted from one location to another. In 1987, the City of Rigby acquired the former West One Bank building for a community center and received grants for renovation. On May 14, 1988, the Rigby City Library, the Jefferson County Historical Society, and the Philo T. Farnsworth Museum moved into the new facility. The building was inadequate but provided an accessible space until another location could be found. In 1992, the City of Rigby obtained a bankrupt mall (the former Bond Motel), and renovation work started in January 1993. Work crews from the St. Anthony's Work Release Program were used to renovate the structure. On July 7, 1993, the Jefferson County Historical Society and Farnsworth and Pioneer Museum merged into one organization. On September 25, 1993, the new home of the Jefferson County Historical Society and Farnsworth and Pioneer Museum was dedicated. (Courtesy JCHS.)

Eight

COMMITMENT TO SERVE

The people of Jefferson County are patriotic and honor the military. They have served in all branches of the America's armed forces and in Idaho's National Guard. From Mexico to Iraq, they have fought in every war and conflict of the past century.

Jefferson County's National Guard units were activated six different times in the 20th century. On June 18, 1916, units of the 2nd Idaho Infantry were mobilized for service on the Mexican border. They were sent to France in World War I, the Pacific in World War II, the Korean War, and the Vietnam War. More recently, the guard has returned from Iraq.

In 1917, Jefferson County saw 846 men register for the draft. All men between the ages of 21 and 30 were required to register. One newspaper account tells the story of a man walking more than 65 miles to register. By the end of February 1918, two hundred men had joined the armed forces; 13 did not return from the battlefield.

During World War II, more than 2,000 young men registered. The first draft lottery was held in October 1940, and more than 800 men were called to serve. Forty-eight made the ultimate sacrifice and did not return home.

The 116th Engineer Battalion was activated on August 25, 1950. All units served in Korea and were discharge after 21 months. Jefferson County lost four men in the Korean War.

The 116th Engineer Battalion was one of the few National Guard units activated during the Vietnam War. It served from May 13, 1968, to September 1969. Jefferson County lost six soldiers in Vietnam, including two from the 116th.

The two major veterans' organizations had active posts in Jefferson County. The American Legion was organized on August 9, 1919, as the Lloyd Crystal Post in honor of Jefferson County's first casualty of World War I. The Veterans of Foreign Wars organized the Snake River Post No. 1,004 on January 7, 1923. Both had members that served in state and national positions addressing veterans' needs and concerns.

In 2008, work began on the construction of a veterans memorial park in Rigby to honor Jefferson County's war dead. While it is being funded through private donations, voters approved funds overwhelmingly for its maintenance.

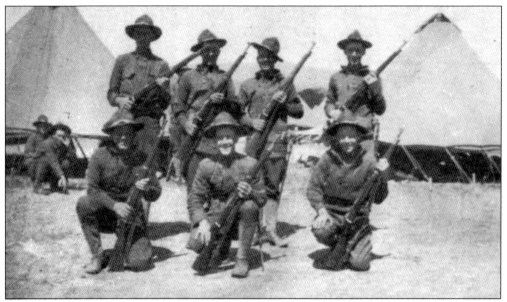

On June 3, 1916, Pres. Woodrow Wilson activated the 2nd Infantry Regiment of the National Guard into federal service to protect the border between the United States and Mexico. The regiment arrived in Nogales, Arizona, on July 12. The Jefferson County group consisted of Philo Anderson, Clyde Ball, Gordon Bennett, Harold Crowder, Harvey Dabell, Clarence Denning, Kember Lessey, and Jack Warner. It patrolled the border until December 8, 1916, and was mustered out on January 22, 1917. (Courtesy JCHS.)

On April 6, 1917, the United States declared war against Germany, and draft laws were signed within a month by President Wilson. By July, the Jefferson County draft board had registered 849 men, and 125 were on their way to Europe. In 1917, the Rigby High School yearbook, *The Periscope*, was dedicated to "those gallant young men who have gone from our midst to offer their lives in the cause of world-wide justice and freedom." (Courtesy JCHS.)

More then 200 Jefferson County men served in World War I. Pictured are four sons of Heber and Carrie E. Ball: Lester J., Earnest, Clyde Mardell, and Glenn L. Ball. (Courtesy JCHS.)

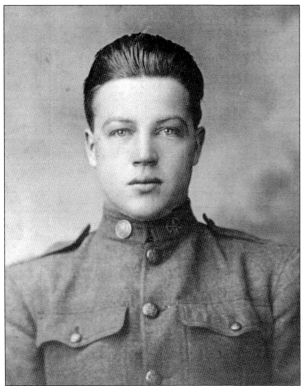

William Lloyd Crystal became Jefferson County's first casualty in World War I. Among the first to volunteer, he enlisted on April 3, 1917, at a mass meeting held in Rigby's tabernacle. He and 28 other Jefferson County men left the next morning for Boise. Within days, President Wilson declared war and Jefferson County's volunteers were outfitted, sworn into federal service, and trained at Fort George Wright in Spokane, Washington. In January 1918, the Idaho regiment was shipped to France, split up, and reassigned as replacements. The driver of his unit's water cart, Crystal was killed by German shells on June 27, 1918. When the American Legion organized a local post on August 9, 1919, they named it the Lloyd Crystal Post. In 1921, his remains were returned to the United States and interred at Arlington National Cemetery. (Courtesy Lois Jones.)

On August 1, 1926, the National Guard was reorganized as the 116th Regiment, 2nd Battalion, Company F. They worked through routine armory and field training. Above, Company F practices for riot duty in 1937. Below, Idaho governor Barzilla W. Clark reviews the 116th Engineer Battalion at Camp Bonneville in Boise on August 16, 1938. (Both courtesy JCHS.)

On May 17, 1937, the Memorial Building was dedicated in Rigby to those who lost their lives in the service of their country. It provided meeting and office space for both the American Legion and the National Guard. In 1965, a new armory was constructed solely for the National Guard. (Courtesy JCHS.)

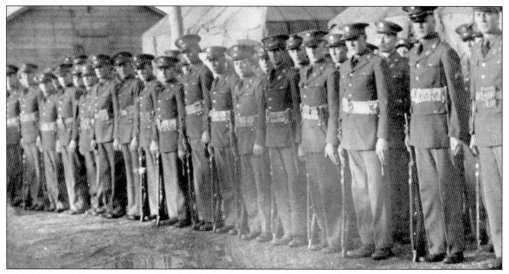

Rigby High School's 1941 yearbook, *The Rodeo*, was dedicated to the Company F, 116th Engineers. They wrote of their pride and extended their "admiration" and "esteem and sincere hope that the future will hold forth for them that degree of success which they richly deserve." They added they regretted the poor quality of the accompanying photograph, writing that "sunless days, rain and mud at Camp Murray conspired against good photography." (Courtesy JCHS.)

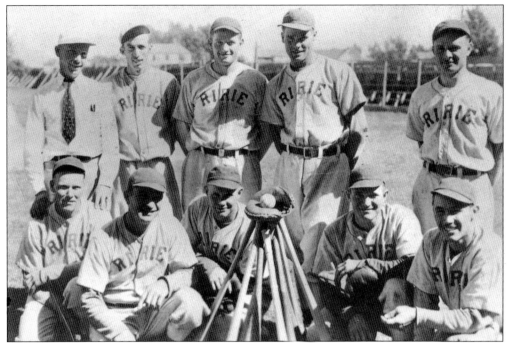

Radioman Bryon D. Mason of Ririe was Jefferson County's first casualty of World War II. He was lost at Pearl Harbor aboard the USS *Arizona*. Mason was remembered as a talented athlete and a professional boxer who had been Idaho's welterweight champion. The photograph shows Mason as a member of Ririe's 1937 baseball team; he is the first one kneeling on the right. (Courtesy BYUI-RB.)

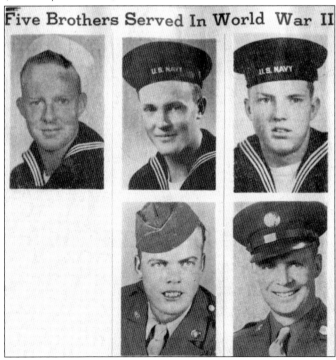

During World War II, the five sons of Lester and Margaret Hoggan Taylor of Lewisville served honorably in the military. Three served in the U.S. Navy, one in the U.S. Army, and one in the U.S. Army Air Corps. (Courtesy JCHS.)

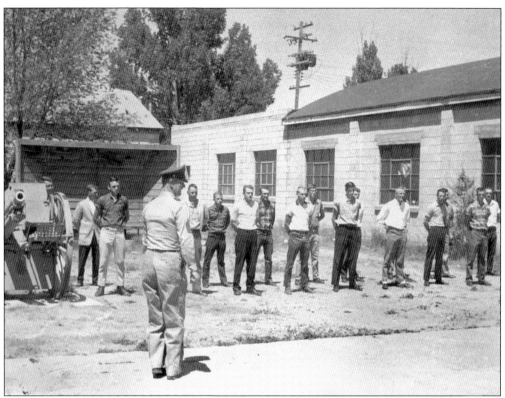

In 1959, departure preparations for new National Guard recruits leaving for basic training were made west of the armory. (Courtesy Jerry O. Jensen.)

In 1965, Jimmy Nakayama of Rigby became Jefferson County's first casualty of the Vietnam War. His tragic death was recounted and memorialized in the 1992 book We Were Soldiers Once . . . and Young and the 2002 movie We Were Soldiers. (Courtesy JCHS.)

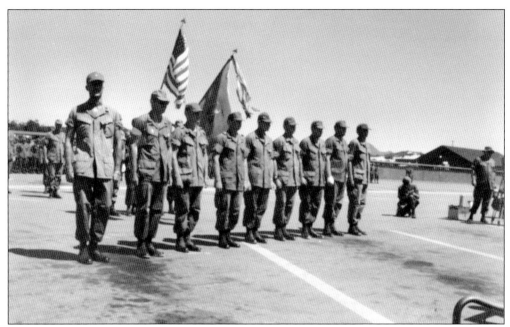

On May 13, 1968, the 116th Engineer Battalion was activated; it was sent to Vietnam in September. They served for 12 months and lost two soldiers. This photograph shows their departure from Cam Ran Bay, Vietnam. Their return in September 1969 was celebrated with parades and parties throughout Jefferson County. (Courtesy Jerry O. Jensen.)

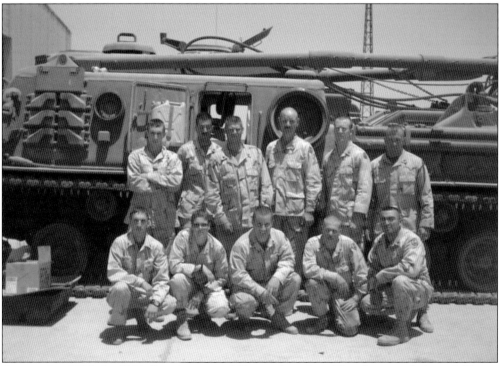

Activated in 2006, the 116th Battalion served 12 months in Iraq. The photograph shows Jefferson County soldiers in Iraq. (Courtesy Timothy Rounds.)

Nine

THE ROCK BUILDINGS OF JEFFERSON COUNTY

The most unique architectural feature of Jefferson County is its rock buildings. Though such structures can be found in Rexburg and Idaho Falls, the large concentration between Hamer and Ririe is remarkable. It is a story that has neither been told nor studied extensively.

As settlers moved into the area, the first buildings were simple log structures. Within a decade, settlers wanted to construct more elaborate and permanent buildings. They turned to the local and readily available black sandstone. The Menan Buttes were only a short distance away, and the smaller Annis Buttes could also be used. It is unknown whether all the rock was quarried from the buttes or from other outcroppings located throughout the county. Many of the buildings also used corners of white limestone quarried near Ririe in Kelly's Canyon. Some of the settlers came from Brigham City and other northern Utah communities known for their own rock buildings.

The largest concentration of rock buildings is in the Menan and Annis areas, closest to the quarrying site. The rock was used in the construction of at least five Mormon churches, one Catholic church, one Presbyterian church, schools, various businesses, dozens of private homes, barns, and countless foundations. Most were built between 1891 and 1930. Many of the structures continue to be used, a few were remodeled and the rock covered over, and others are just memories, having been razed.

The first building constructed was the Menan LDS Ward House. It was started in the spring of 1891 and was completed in 1899. The rock was quarried from the south side of the Menan Buttes. The last public building constructed was the additions to the Annis Ward Church in 1936 and 1968.

Much of this story remains to be told. Little information and no photographs have been found of the construction of these buildings and their builders.

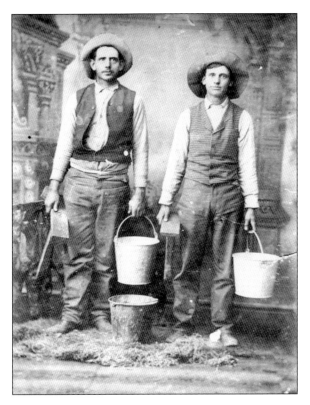

Bertrand Tanner and his brother-in-law Lee Barry operated a rock quarry across the river from the Menan Buttes around 1900. No photographs have been located that show the actual quarrying of the sandstone. (Courtesy JCHS.)

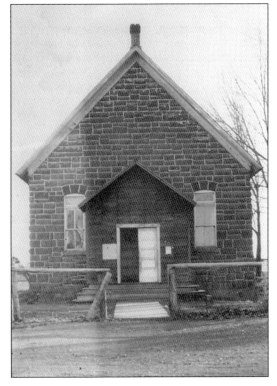

On October 23, 1904, the Annis LDS Ward was organized with George A. Browning as its first bishop. In 1905, work began on the construction of a new ward meetinghouse. The black sandstone was hauled from a quarry 10 miles northwest. While most of the labor was donated, skilled masons and carpenters were hired when necessary. On July 14, 1904, the first meeting was held in the new building. It was not dedicated until all debts were paid in 1917. (Courtesy JCHS.)

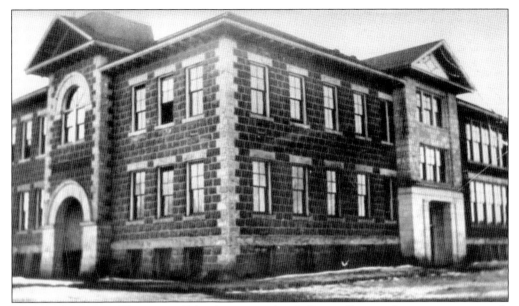

In 1909, the Menan Elementary School was completed. Originally a single-story structure with four large classrooms and two rooms in the basement, it was later enlarged and became a two-story structure with four new rooms, a principal's office, a lunchroom, and a furnace room. The school was used for 50 years. (Courtesy JCHS.)

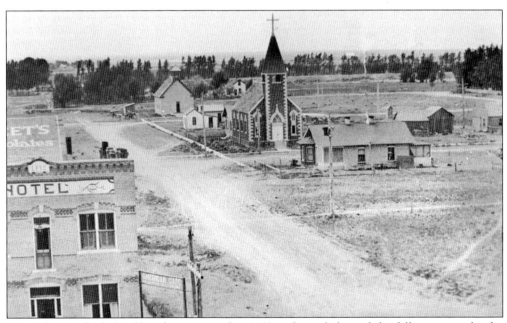

St. Anthony's Catholic Church was started in 1910 and was dedicated the following year by the bishop of Boise, Right Reverend A. J. Glorieux. It was the second church built in Roberts. It was razed in 1979, just a year after it had been placed on the National Register of Historic Buildings. This photograph shows St. Anthony's in 1919. (Courtesy JCHS.)

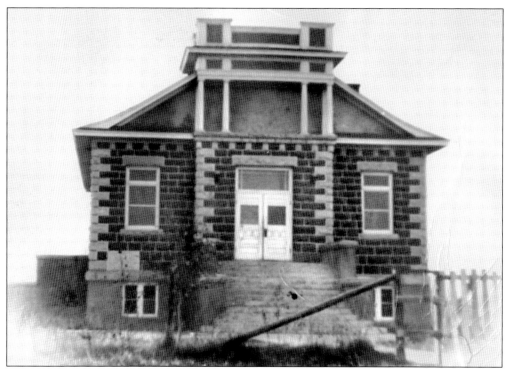

In 1924, the Lorenzo Ward Chapel was built of black sandstone quarried from the Menan Buttes at a cost of $17,000. It was dedicated the following year by LDS Church apostle Stephen L. Richards. It served the area for more than 38 years. (Courtesy JCHS.)

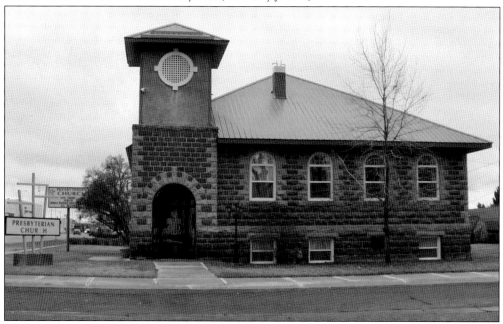

On December 30, 1923, the Rigby Presbyterian Community Church dedicated its new and completely paid for building on the corner of First North and State Streets. The sermon was preached by Reverend Baird and the music was supplied by the Ririe and Rigby choirs. (Courtesy PLS.)

The Hamer Mercantile opened in the 1920s and closed in 2005. It is constructed with black sandstone rocks not quarried from the Menan Buttes but collected from smaller outcropping in the area. (Courtesy PLS.)

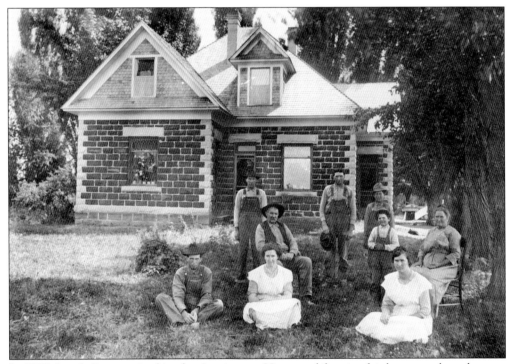

In 1880, Josiah Scott arrived in the Annis area. He started farming his homestead on the west side of the Annis Buttes in 1883. He originally built a log house, barns, a granary, and a root cellar. This black sandstone house was built between 1908 and 1910. The photograph shows the Josiah and Mary Scott family in front of their home in 1918. In 1982, it was added to the National Register of Historic Buildings. It has been vacant since 1974. (Courtesy Eldon Scott.)

The A. P. Smith home is located on west Main Street in Rigby. It was constructed by former Rigby mayor and businessman A. P. Smith about 1920. (Courtesy PLS.)

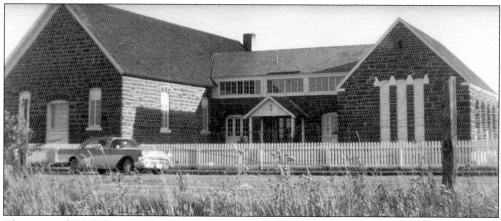

The original LDS Annis Ward meetinghouse was enlarged and remodeled twice (1936–1944 and 1968–1969). With the reorganization of LDS Rigby Stakes, the Menan Stake was created and ward boundaries were redrawn. The building was sold and now houses a private school. (Courtesy JCHS.)

Ten

THE UNEXPECTED
BLIZZARDS, FLOODS, FIRES, OUTLAWS, AND MORE

The flow of Jefferson County's history has been disrupted by unexpected events, natural disasters, and human tragedies. While some events have been relatively minor, others have had major effects on the community and may have changed the course of history. Residents have spun tales about others, and the stories have entered the realm of legend.

High winds are common in Jefferson County. Each year, I-15 is closed north of Idaho Falls for dust storms in the spring and blizzards in the winter, causing traffic to be diverted to state highways. School districts plan snow days for winter school closings. The blizzards of 1989 paralyzed the area, closing schools for days and killing thousands of heads of cattle, sheep, and horses.

While flooding is part of life on the Snake River Plain, the Teton Dam Flood of 1976 did not create the common high waters of spring. Losses were huge, and hundreds of homes were damaged or destroyed.

Hundreds of fires have occurred in the history of Jefferson County. Most have been small or private structures. Some fires have permanently closed businesses or schools. Others have been costly inconveniences that reinforced owner's determination to rebuild and to continue in business. Each event has its own story to be told.

In June 1911, Hugh Whitney, a Soda Springs sheepherder, was robbed while he slept in Monida, Montana. He and a friend suspected the bartender and robbed the saloon, taking the money and liquor. The two men then boarded the southward train. Notified of the robbery, Fremont County deputy sheriff Sam Milton boarded the train in Spencer and attempted to arrest the two men. While their weapons were surrendered, Whitney started fighting the deputy and overpowered him. He retrieved his gun and shot him twice. The train's conductor, William Kidd, tried to rescue the deputy, but Whitney shot him too. Kidd died the next day. The two men pulled the signal cord, jumped off, and ran into the sagebrush. His companion returned to Montana, while Whitney continued to run and hide. He stopped at the McGill Ranch near Hamer and was recognized by 17-year-old Edgar McGill, who attempted to disarm him. Whitney shot him, took his horse, and continued traveling south. The *Rigby Star* reported these events and the rumors that surrounded them. (Courtesy *Jefferson Star* and BYU–Idaho.)

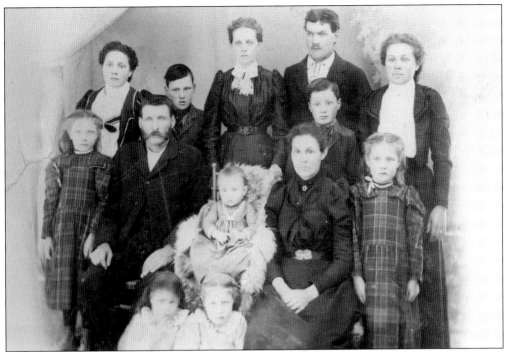

W. R. "Rube" Scott (1855–1945) was a colorful character. He always wore a 10-gallon hat and cowboy boots. In 1911, he was Menan's constable. When he was notified of Whitney's flight south, Scott went alone and waited at the bridge. When he heard a horse crossing the bridge, he called "Halt in the name of the law, or I'll shoot!" He then fired a warning shot. Immediately Whitney shot in the direction of the gunfire. Scott tried to shoot again but couldn't. His gun finger had almost been shot off. Whitney escaped, and Scott sought a doctor to complete his finger's amputation. This image is of the Scott family around 1907. Rube is to the left in the second row with mustache. (Courtesy JCHS.)

This wanted poster offers a $1,500 reward for Whitney dead or alive. Several posses hunted Whitney. Reportedly he and his brother Charles robbed a bank in Cokeville, Wyoming, in 1912 and then disappeared. For years, sightings were rumored throughout eastern Idaho and western Wyoming. Whitney was never found. In 1952, Charles Whitney sought clemency from Wyoming governor Frank Barrett. He reported that Hugh Whitney had died in Canada in 1951. (Courtesy JCHS.)

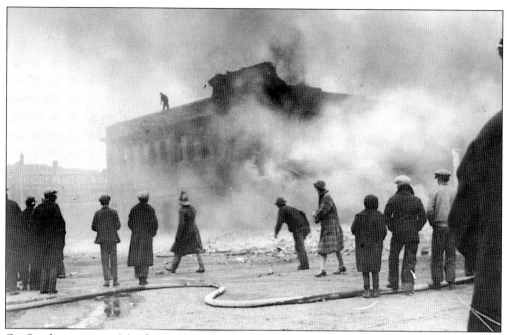

On Sunday morning, March 26, 1926, the Quality Store was destroyed. The fire started in the rear and quickly spread from the basement to the roof. The fire was fanned by a 50-mile-an-hour gale, and within 30 minutes, the entire structure was enveloped in flames. (Courtesy JCHS.)

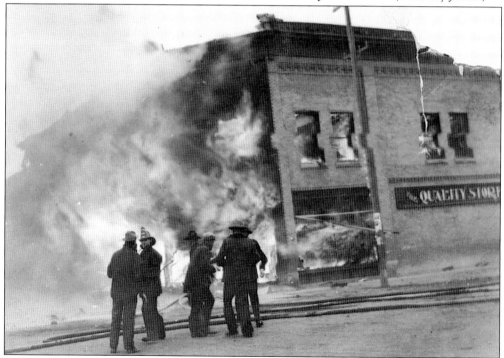

The Quality Store was a total loss and was never rebuilt, but firefighters were able to stop the blaze from spreading to other buildings. This photograph shows firefighter Russell Bates in the back center, and he is standing on store's roof in the image at the top of the page. (Courtesy JCHS.)

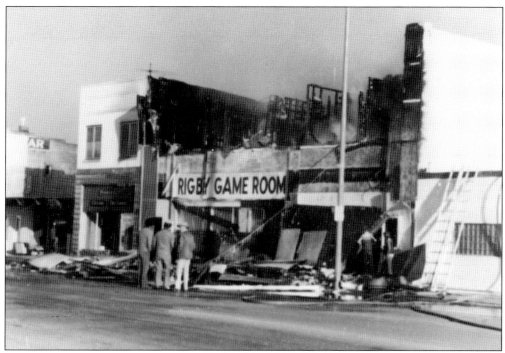

When the Quality Store burned in 1926, the adjacent Royal Theater survived with only minor water damage. On September 29, 1919, the theater opened its doors for the first time with 800 in attendance. Just days before its reopening after extensive remodeling, it burned to the ground in the spring of 1979. It was the last operational movie theater in Jefferson County. (Courtesy JCHS.)

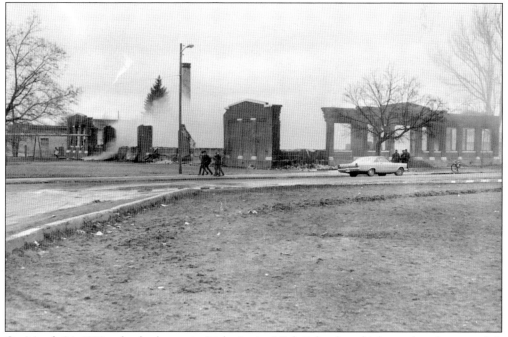

On March 24, 1971, a fire broke out in Rigby Junior High School, and it burned to the ground. It was a total loss, with only the chimney and some blackened walls remaining. (Courtesy JCHS.)

Between November 3, 1944, and April 1945, the Japanese launched more than 9,000 hydrogen balloons with bombs and incendiary devices. While only 300 were found or observed, 1,000 were believed to have reached North America. On February 22, 1945, a balloon landed 3 miles east of Rigby. It was reported to be the first wholly intact balloon the U.S. Army had recovered. It contained a 10-pound incendiary device and a 30-pound explosive that failed. The story was kept secret until after the war. In May 1945, a balloon exploded in Oregon, killing a minster's wife and five children. (Courtesy JCHS.)

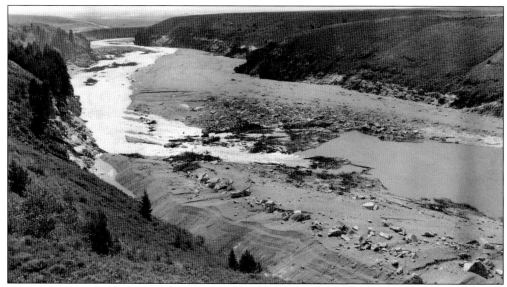

On Saturday, June 5, 1976, the Teton Dam failed. The dam was on the Teton River, a tributary of the Snake River, and water rushed through the Teton Canyon, devastating the communities of Wilford, Sugar City, and Rexburg. This photograph shows the Teton Dam on June 9, four days after its collapse. (Courtesy JCHS.)

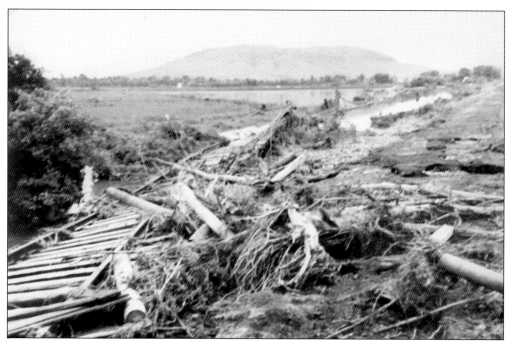

The floodwaters of the Teton Dam spread west of Rexburg and entered the North Fork of the Snake River and went around the Menan Buttes. The waters continued west and south, causing extensive damage in the Menan area. The floodwaters reached Roberts at 6:00 a.m. on Sunday, totally submerging the community for days. The railroad tracks trapped the waters in the community, and the railroad refused to have them breached. It would be two weeks before all waters were drained. Residents were not allowed to visit their homes until Thursday. The picture above shows the twisted railroad tracks north of Menan. The picture below shows the flooding in Roberts on June 8, looking east from the I-15 Freeway exit. (Both courtesy JCHS.)

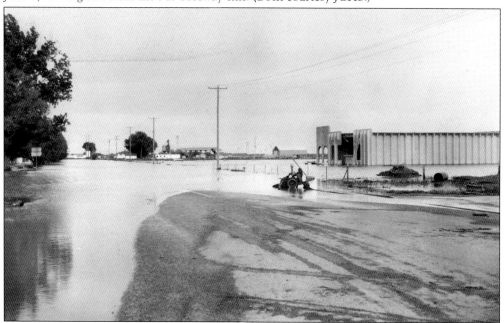

On February 1, 1989, a "Siberian Express" blew through eastern Idaho. While Clark County was the hardest hit, parts of Jefferson County were also battered. The storm dropped more than 3 feet of snow, wind whipped over 45 miles per hour, and windchill temperatures dropped to 112 degrees below zero Fahrenheit. Drifts piled up to 15 feet. Livestock were covered in a mass of snow so badly the cows could not see. The drifts froze so hard that the cattle could walk on them. While winds continued for five days in Hamer, just 8 miles south the sun was shining. West of Hamer, in Terreton and Monteview, it was calm and peaceful. While the winds were localized, the frigid temperatures enveloped all of eastern Idaho. When temperatures dipped below minus-30 degrees, all school districts in Jefferson County closed for days. One elderly woman froze to death after she fell in her garage and was unable to get up. Above, the blizzards blow through Hamer. The picture below shows the "tunnel roads" in Hamer with 15-foot drifts. (Both courtesy Dave Sanders.)

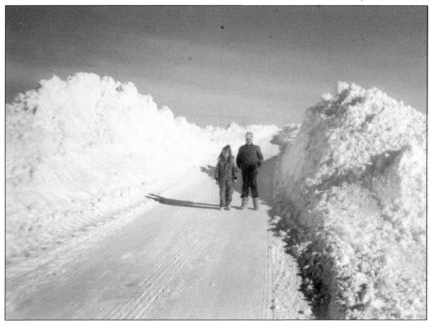

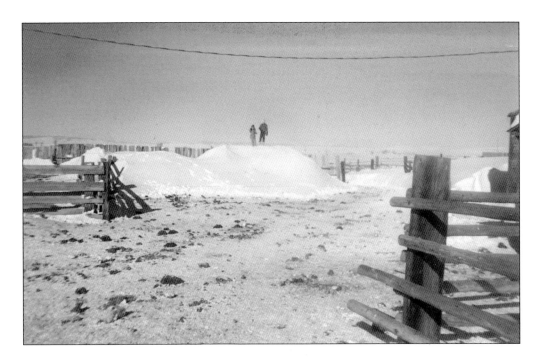

For five days, roads were closed, and many ranchers and farmers were unable to reach their stock. Drifts were said to be "as high as barns." The picture above shows how cattle walked up the drifts and got out of their corrals. While stock losses were small in Jefferson County, they were tragically high in Clark County, as cattle, sheep, and horses froze to death. Abs Laird, a Clark County commissioner, lost his entire herd of cattle. The picture below shows a few of his losses. (Both courtesy Dave Sanders.)

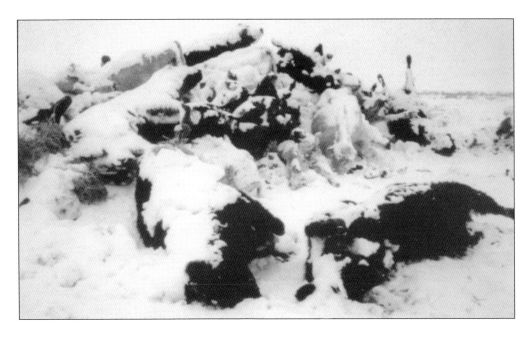

BIBLIOGRAPHY

Adams, Willard. *100 Years of Jefferson County*. Rigby, ID: self-published.
Anthony, Betty, et al. *Ririe: Our Home Town*. Self-published, 1990.
Arrington, Leonard J. *History of Idaho*. Two volumes. Moscow and Boise, ID: University of Idaho and the Idaho State Historical Society, 1994.
Beazer, A. Richard and S. R. Thomas. "History of Lorenzo, Idaho, 83432."
Carter, Kate B., ed. *Pioneer Irrigation: Upper Snake River Valley*. Salt Lake City: Daughters of the Utah Pioneers, 1953.
Clements, Louis J. *Centennial Farm Families*. Vol. 1. Rexburg, ID: Upper Snake River Valley Historical Society, 1991.
Crowder, David L. *Tales of Eastern Idaho*. Idaho Falls, ID: KID Broadcasting Company, 1981.
Fillmore, Gwen Berrett, Elaine Brinton Poole, and Fontella Bitton Spelts. *Menan, Idaho, 1879–1986*. 1986.
Fisher, Vardis, ed. *The Idaho Encyclopedia*. Caldwell, ID: Caxton Printers, 1938.
Forbush, Harold S. *Education in the Upper Snake River Valley: The Public Schools (1880–1950)*. Rexburg, ID: Ricks College Press, 1992.
Godfrey, Matthew G. *Religions, Politics, and Sugar: The Mormon Church, the Federal Government, and the Utah-Idaho Sugar Company, 1907–1921*. Logan: Utah State University Press, 2007.
Hamer Friends of the Library. *Time Goes By: People Pass On or Move Away*. Hamer, ID: Hamer Friends of the Library, 1991.
Heaton, John W. *The Shoshone-Bannocks: Culture and Commerce at Fort Hall, 1870–1940*. Lawrence, KS: University Press of Kansas, 2005.
http://imnh.isu.edu/digitalatlas/
Idaho Yesterdays. Idaho Historical Society, 1975–present.
Lee, Eldred. *The Great Feeder Canal: A History*. Self-published: 1998.
Lindstrom, Joyce. *Lewisville Centennial, 1882–1982: the History of Lewisville, Idaho*. Rexburg, ID: Ricks College Press, 1982.
Lovell, Edith Haroldsen. *Captain Bonneville's County*. Idaho Falls, ID: Eastern Idaho Farmer, 1963.
Madsen, Betty and Brigham H. Madsen. *North to Montana!: Jehus, Bullwhackers, and Mule Skinners on the Montana Trail*. Salt Lake City: University of Utah Press, 1980.
Market Lake Centennial Committee. *Market Lake Centennial, 1867–1967*. Roberts, ID: Market Lake Centennial Committee, 1967.
Pettite, William Stibal. *Memories of Market Lake: A History of Eastern Idaho*. Four volumes. Self-published: 1973–1999.
Pieper, Henry W. and Mary O. *Rigby Idaho Stake History*. Rexburg, ID: Ricks College Press, 1984.
Scott, Patricia Lyn. *The Hub of Eastern Idaho: A History of Rigby, Idaho, 1885–1976*. Caldwell, ID: Caxton Printers, 1976.

Snake River Echoes. Upper Snake River Valley Historical Society, 1974–present.

Staley, Mildred. *Mud Lake Memories.* Mud Lake Historical Society and Museum, 2005.

Thompson, Edith M. Schultz and William Leigh Thompson. *Beaver Dick—The Honor and the Heartbreak: An Autobiography of Richard Leigh.* Laramie, WY: Jelm Mountain Press, 1982.

Wiggins, Lou Jean S., comp. "Settlement of Idaho by Utah Pioneers: Bingham and Jefferson Counties." *Pioneer Pathways* 8: 257–308. Salt Lake City: International Society Daughters of Utah Pioneers, 2005.

Across America, People are Discovering Something Wonderful. Their Heritage.

Arcadia Publishing is the leading local history publisher in the United States. With more than 4,000 titles in print and hundreds of new titles released every year, Arcadia has extensive specialized experience chronicling the history of communities and celebrating America's hidden stories, bringing to life the people, places, and events from the past. To discover the history of other communities across the nation, please visit:

www.arcadiapublishing.com

Customized search tools allow you to find regional history books about the town where you grew up, the cities where your friends and family live, the town where your parents met, or even that retirement spot you've been dreaming about.